INFORMATION GRAPHICS

AND VISUAL CLUES

ROCKPORT

First published in the United States of America by
Rockport Publishers, Inc.
33 Commercial Street
Gloucester, Massachusetts 01930-5089
Telephone: (978) 282-9590
Fax: (978) 283-2742
www.rockpub.com

Library of Congress Cataloging-in-Publication Data

Lipton, Ronnie.
 Information graphics and visual clues : communicating information
through graphic design / Ronnie lipton.
 p. cm.
 ISBN 1-56496-864-2
 1. Commercial art—Technique. 2. Graphic arts—Technique. I. Title.
NC1001 .L57 2002
741.6dc21 2002004536

ISBN 1-56496-864-2

10 9 8 7 6 5 4 3 2

Design:
HATMAKER

Production and Layout:
LAURA HERRMANN DESIGN

Jacket Design:
BLACKCOFFEE DESIGN

Printed in China

GLOUCESTER MASSACHUSETTS

ROCKPORT PUBLISHERS

INFORMATION GRAPHICS
AND VISUAL CLUES

RONNIE LIPTON

contents

introduction

"Be seen, be heard, be noticed, be remembered." The mission/slogan of Tim Kenney Marketing Partners in Bethesda, Maryland, sums up the task and the goal of every graphic designer approaching every project: not just to send a message, but to have it received, absorbed, recalled. And, as you know, it takes intelligent graphics—graphics that *speak*—to achieve that goal instantaneously.

It takes graphics because they communicate preverbally. Viewers see and "get" them before they ever read a word. In fact, graphics may be all that foreign, illiterate, or even busy or stressed viewers get, so they depend on universal images that tell the story without words. Other viewers use their first graphic impression to make the decision to read or not. Although type isn't out of fashion, viewers have to spend more time to absorb the biggest, boldest words than they do for graphics, and research shows a trend toward people's not bothering—unless they have enough motivation.

Research also supports the power of graphics and their status as the first point of visual entry into a design. (It also supports the power of clichés: What's the verbal equivalent of one picture? If you've heard the answer once, you've heard it a thousand times.)

Even world powers have had some recent lessons in the power of visuals and information graphics:

- Many people blame (or credit, depending upon their party) the Republican victory in the 2000 U.S. presidential election on an election ballot's misleading design.

- Can you picture officials of the U.S. Pentagon engaging in a color debate? In November 2001, the Department of Defense decided to change the color of food packets airdropped in Afghanistan. They had been yellow, the same color as canisters of unexploded bomblets from cluster bombs dropped in the same country. The United Nations and human rights groups complained that hungry civilians could be injured if they confused the two, so the Pentagon planned a switch to blue.

- At the heart of the much-publicized 2002 introduction of the euro currency is an information graphics story: the symbol's design. Jean-Pierre Malivoir, euro mission chief for the European Union, and his team combined parallel straight lines—inspired by those on the dollar, yen, and pound sterling symbols—with the Greek letter epsilon...an E for, of course, Europe.

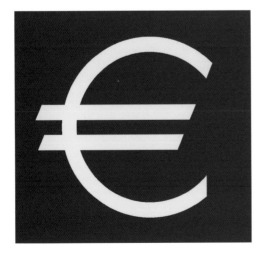
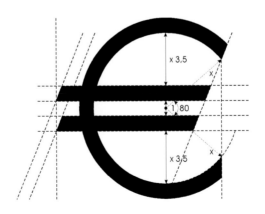

A well-conceived and well-executed graphic makes words unnecessary or at least secondary. In one memorable ad, an almost blank page sent a graphic message that spoke volumes. Picture white glossy paper, bare except for just a small photo of the product on the lower right-hand corner of the page.

The product?

Bleach.

Oooh!

Behold the blank page. You know that the ad works on two levels. First, when clutter is all around, as it is in a magazine, viewers will be drawn to the emptiness, if only to wonder if something was left out. That's the same thinking behind a lone black-and-white ad in a sea of color (when the reason's not budgetary). Remember that old ad slogan: "If you want to get someone's attention, whisper"? Second, once at the page, the viewer can't help but notice how well the almost blinding brightness demonstrates the product's benefit.

It would be nice to be able to tell you that the ad sold a lot of bleach, but it couldn't. You won't be surprised because it's happened to you: That brilliant concept never ran, rejected by the client (in this case, because it didn't fit the brand's positioning).

You'll find this book packed with design concepts that did make it past the clients into print and into the minds of viewers. Chapters are divided into types of work—logos, posters, etc.—except where it made more sense to group diverse pieces that were part of the same identity. You'll find plenty of examples of graphics systems—visual codes—that wordlessly tell viewers what they're looking at, into which category it falls, or where to look for what.

Many of these effective information graphics help viewers find their way— through a building, a city, a publication. They're all designed to actively engage the viewers, to reach out and touch them (as still another ad slogan goes).

In fact, these graphics communicate so compellingly that you shouldn't need words to get them. That doesn't mean you won't find any words (I lost that argument with my editor!). Text with each graphic deconstructs the creative process, taking you behind the scenes to each designer's intention. So you'll also find plenty of inspiration to push the power of your own graphics.

"Be seen, be heard, be noticed, be remembered." Strong words, yet even that message comes across more quickly and powerfully in graphic form, so that's how the design firm sends it.

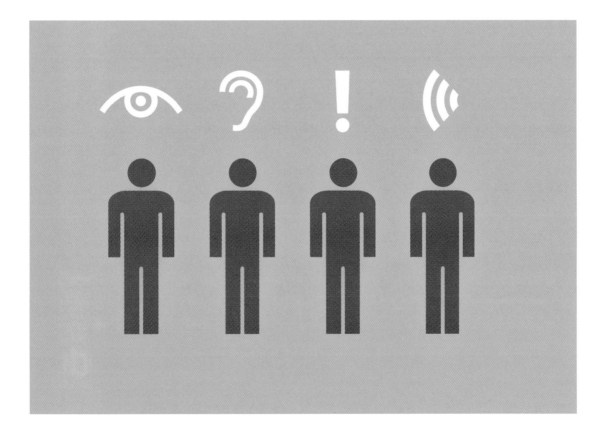

Tim Kenney Marketing Partners

Project: Web site, postcard
Design Firm: Tim Kenney Marketing Partners

Sensory icons and punctuation help to state the mission of a design firm: "Be seen, be heard, be noticed, be remembered." The image debuted on the firm's Web site, where the design goal was simplicity. "No one wants to wait for images…eye candy takes a long time to download." Tim Kenney said.

Take it as a design challenge when people say, "You can't judge a book by its cover." If they happen to be speaking literally, they must be referring to designers (no one you know, I'm sure) who come up with covers from only the titles. But if the designer begins by reading or viewing the contents, discussing it with its author, and learning about its audience, there's no reason why the cover shouldn't give visual clues to the contents within. You know there's no excuse to skip that process.

A well-designed, well-researched cover sets the tone for the contents. And the same holds true for product packaging, not just covers of books and other media. It's not only safe; it's essential to assume the product you're designing will compete with a crowd of others in the same category. These days, products even have to compete outside of their categories.

publication identity systems

Chapter One

To vie for the discretionary time of an increasingly impulsive yet selective, always demanding audience, "pretty" won't cut it. An effective cover has to inform and intrigue. It has to represent the product. And it has to do it quickly—a need that always points to clear graphics in place of words.

In this chapter, you'll also find samples of the contents, with information-design systems that inform an entire publication. Annual reports as a category are cases in point. Most contain themes that drive the design from the cover through the book. It's practically a rule to fill them with big, appealing, informative graphics—starting with the cover—to make the company look good and to relieve the monotony of pages of numbers.

Of course, anything that's a rule demands to be broken, so some annual reports break it for effect...or for budget. (When it's the budget talking, the challenge usually is to create design so effective, it looks instead like a decision made by design).

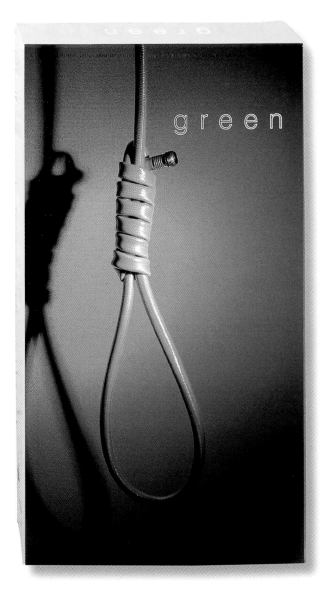

Two Birds Film Company

Project: Video packaging
Design Firm: Group Baronet
Creative Director: Meta Newhouse
Designer: Brad Galles
Photographer: Sam Martinez

A noose made from a water hose illustrates the thesis put forth in the documentary: discriminatory corporate negligence in poisoning water supplies.

The documentary explores the area between Baton Rouge and New Orleans, Louisiana, nicknamed Cancer Alley, because it reports levels of toxic emissions in the water that are the highest in the United States. The designers chose the powerful noose image to convey the high death rates in this community. Because a noose also suggests lynching, the image hints at "the politically charged nature of this film."

Poor African-Americans make up the largest portion of the area's population. The documentary charges that the plastic companies that pollute the water are practicing racism and elitism as well as pollution. The film makes the case that the companies continue to pollute in the belief that the affected community is too uneducated to speak up, and too poor to afford good legal counsel.

More significance: that's not a rope tied into a noose; it's a water hose, and one with an ominous-looking shadow. The noose is green like the title, and like many hoses. The color may stand for the environment, but it's also the color of water you don't want to drink.

Epinions

Project: Identity system
Design Firm: MetaDesign NorthAmerica
Designer: MetaDesign NorthAmerica

Epinions.comSM

The good…

and the bad

What's your opinion?

Buy it!

Epinions, a consumer-oriented Internet company, required an identity that would reflect their then-unique business proposition—an online database of product and service reviews that would be built and driven by the users themselves, not by professional reviewers. To fulfill their requirement, Epinions turned to MetaDesign NorthAmerica.

As part of their branding process, MetaDesign worked with its client to arrive at a core set of parameters that would guide the development of the identity. They decided that the design should demonstrate a sense of informing, transparency (Epinions did not want its corporate identity to overwhelm the site since it was to be driven by the consumer), and passion (the consumers should feel passionately about whatever they reviewed). Community was yet another attribute Epinions wanted its identity to convey. To gain a sense of scale and breadth, MetaDesign also discussed possible applications that ranged in size from a small Internet link icon to an oversized billboard. Finally, Epinions provided one last piece of information—a roughly sketched head made out of a backward, lowercase *e* that was its existing identity.

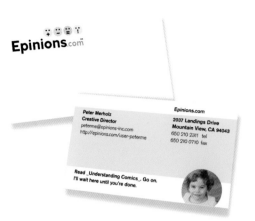

With these parameters in mind, MetaDesign produced four different identity directions. "Because we had such a great working relationship with our client, we allowed their creative director to review some of the work while it was still in progress," said Sandy Speicher, who created the identity that was ultimately selected. "The creative director helped refine and shape the directions in which we were heading." So, when MetaDesign presented four solutions, it was clear to Epinions that the chosen direction best brought their brand to life.

"We then went through countless rounds of exploration to make sure that the color, typography, shapes of heads and eyes, facial expressions, and punctuation were just right," Speicher added. By turning the now ubiquitous emoticon on its head, MetaDesign provided the client with a complete communication system that not only integrated the four-tiered rating system, but also extended to both digital and traditional media.

Epinions.com

| AUTOS | BOOKS | MOVIES | MUSIC | COMPUTERS | ELECTRONICS | HOME & GARDEN | KIDS & FAMILY | SPORTS | TRAVEL | STORES | MORE... |

Sign up! | Home | Help | Sign in [] [Search]

97% of people recommend **Kitchen Aid Ultra Power KSM90 Stand Mixer**. Compare prices before you buy at Epinions.com.

Home » Home & Garden » Small Appliances » **Kitchen Aid Ultra Power KSM90 Stand Mixer** Email this page

Product Information
Product Overview
Reviews
Latest Prices
Full Specs

Shopping Tools
Recently Viewed Items
Save to my Wish List
Get Review Alerts
Email this page

Share Your Opinion
Write a review!

People who like this item also like:
Kitchen Aid 5-Speed Ultra Power Blender KSB5
Regalware Kitchen Pro Breadmaker K6745S
Kitchen Aid Classic Series K45SS Stand Mixer
Kitchen Aid 11-Cup Ultra Power Food Processor KFP600

Find other items in:
KitchenAid Small Appliances
Mixers Small Appliances

Kitchen Aid Ultra Power KSM90 Stand Mixer
View larger photo

★★★★★
97% Recommended

Ease of Use:	▬▬▬▬▬	4.5
Durability:	▬▬▬▬▬▬	5.0
Ease of Cleaning:	▬▬▬▬▬	4.5
Style:	▬▬▬▬▬	4.5

Based on 74 member reviews

Empire Red
Model KSM90ER

Compare Prices

Sort by Store	Sort by Store Rating	Item Details	Sort by Price	
Cooking.com	★★★★☆ 5 reviews	KitchenAid Black Stand Mixer	$219.95	Check Latest Price
Cooking.com	★★★★☆ 5 reviews	KitchenAid White Stand Mixer	$219.95	Check Latest Price
Cooking.com	★★★★☆ 5 reviews	KitchenAid Imperial Grey Stand Mixer	$219.95	Check Latest Price
Cooking.com	★★★★☆ 5 reviews	KitchenAid Green Stand Mixer	$219.95	Check Latest Price
Cooking.com	★★★★☆ 5 reviews	KitchenAid Metallic Grey Stand Mixer	$298.95	Check Latest Price
J&R	★★★☆☆ 11 reviews	KITCHEN AID KSM-90 White KA KSM90WH	$199.99	Check Latest Price

Association of Croatian Architects

Project: Journal
Design Firm: Cavarpayer
Designers/Illustrators: Lana Cavar, Narcisa Vukojević
Designer: Ira Payer

*A pregnant belly unveils
an architectural journal's
new design and the issue's
theme: production.*

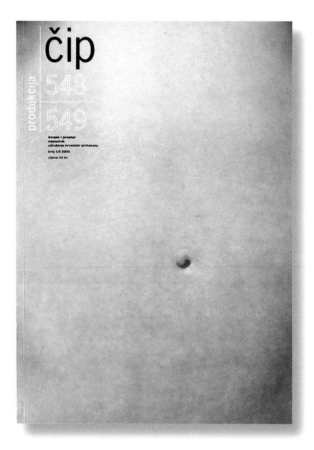

CIP, short for *Covjek I Prostor (Man and Space)* is the journal of the Association of Croatian Architects. The journal has been published for fifty years and redesigned four times. The designers of the latest incarnation showed off the journal's longevity by building oversized issue numbers into the banner (see facing page).

Each publication—and cover design—follows a theme. For example, a full-bleed photo of a pregnant belly illustrates the production (*produkcija*) issue. The illustration is made more relevant because it was also the first issue of the redesign (the baby arrived before the magazine did).

Two other issues focus on education (*edukacija*), with the first issue exploring that of Croatian architects; the other, of architects abroad. The designers used the hangman game as it might be drawn in a student's notebook to compare the two. On the cover of *Edukacija I,* the Croatian players are represented as losing the game, and those taught elsewhere are winning, as shown on *Edukacija II.*

On two education themed issues,
a game of hangman drawn as if on a
student notebook shows architects
schooled in Croatia losing the game
(left), and those abroad winning it.

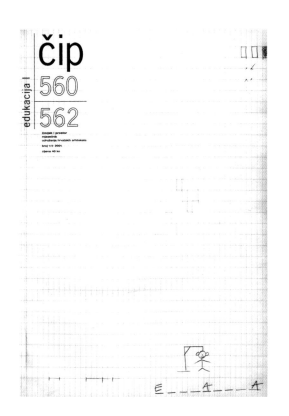

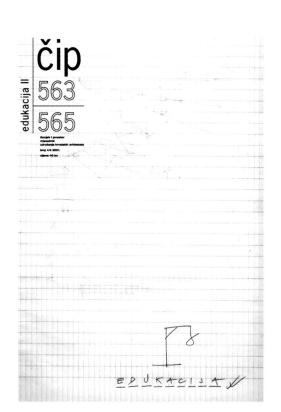

The illustrations were the designers' and editors' commentary on the local architecture school with its "professor-oriented education where students are less important" than the teachers, designers Ira Payer and Lana Cavar wrote. The covers scored a desirable impact for a journal that's meant to provoke thought. They "caused a quiet mess" at the local school, and a meeting of professors to discuss this public attack: "We were very passionate about the education issue, as we were students [there] just two years ago."

The hangman game itself seems an interesting choice of image, given the war crimes committed in the past decade in the Balkan wars, but the designers mentioned no such inspiration.

Parsons School of Design

Project: Catalogs
Design Firm: Parsons School of Design, Promotion Design
Creative/Art Director: Evelyn Kim
Designer: Meg Callery
Photographer: Marty Heitner
Producer: Tom Overgard
Production Assistants: Alvida McGlashan, Ismael Quintero

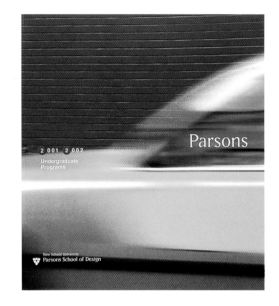

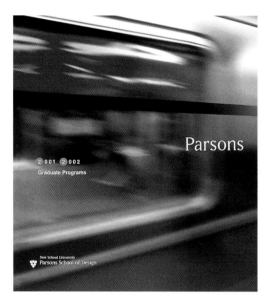

Blurred images of a cab and a subway car remind students of the fast-paced city around the art school.

The New York location is a big selling point to prospective students of Parsons School of Design, so the city is the theme for the school's 2001–2002 undergraduate and graduate program catalogs. The books reflect the designers' philosophy of heading toward design solutions that are unexpected for an art school. "If we reject an idea, it's the one that would be considered typical," Evelyn Kim said.

In that spirit, one catalog cover features a taxicab; the other, a subway car: "two typical New York icons portrayed in atypical styles," Kim said. The colors and blurred images suggest the speed, style, and energy of the city, and the atmosphere around the school. Bleeding the photos and extending them across the perfect-bound spine to fill the back covers reinforces the idea of the surrounding atmosphere.

The circle shape repeats to flag folios and the school's proximity to attractions on a map of the city.

Navigational color codes are introduced on the back covers or table of contents. The code's dual locations help students find their chosen department from whichever end they approach the book. It's the department's initial reversed out of a circle of color, one color for each department or each set of departments that share an initial.

The colors correspond to 2 1/2-inch (6 cm) tabs at the upper right of every right-hand page, so they're visible on the trim edge even when the book's closed. The colors also distinguish some page backgrounds, and the folios—reversed out of the same circles as those behind the department initials.

To reinforce the desirable-location theme, a map of the school on the inside front covers shows the school's geographic relationship to places that are likely to attract art students.

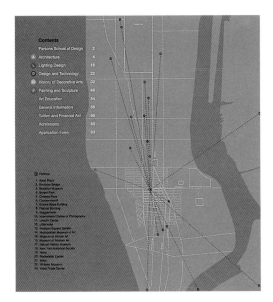

Color-coded, encircled department initials correspond to tab colors and other elements to guide catalog readers.

Collateral Therapeutics

Project: Annual report/portfolio
Design Firm: Cahan & Associates
Art Director: Bill Cahan
Art Director/Designer/Illustrator/Copywriter: Kevin Roberson
Photographer: Robert Schlatter
Copywriter: Thom Elkjer

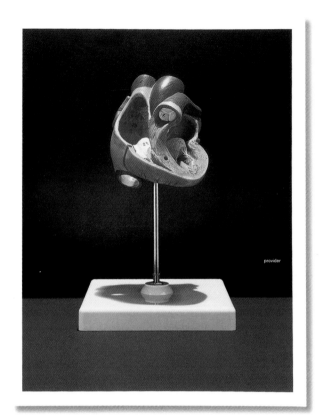

The heart model reappears in various angles to serve as diagrams superimposed with callouts. Different views help to connect to different traits.

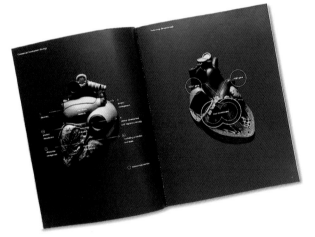

Photographic studies of a laboratory heart model are labeled with various heartlike (and human) traits.

An annual report for a company that develops nonsurgical gene therapy methods to treat cardio-vascular disease has got to have heart. The book features a variety of photos and diagrams of hearts to illustrate the complicated work of the company.

Pink paper for the financial pages, and some mauve type "pick up some of the hues in the tissues of the heart," said designer Kevin Roberson. The book also "employs pacing as a graphic system," he said. "Unfolding the story bit by bit allows clear and memorable communication."

A cardboard slipcase with the same heart-model cover illustration holds the annual report and a portfolio developed the year before. In the portfolio, graphic depictions make it easy for readers to grasp statistics. The graphics show the urgency of the company's work through images of people who have died from heart disease or who have been treated unsuccessfully.

For example, a series of blurry photos of victims with their names count down the seconds, to illustrate the disease's death rate: one American every minute. That's also shown on a page of numerical equations, relating the passing seconds to numbers of deaths. Other chilling illustrations: White crosses (diagonal crosses, not religious ones) print over one or more of the people in a group photo; a simple horizontal line crosses out many of the names in a multicolumn listing.

Reflecting a different statistic—the number of cardiac procedures performed every hour—each of four pages shows numbered sepia-tone 1950s-vintage photos of one hundred patients. The second half of the portfolio is illustrated with the goal of the company's research: patients living productive lives. "Old black-and-white photos are useful in implying memories and time passing —an easy jump to life passing away," Roberson said.

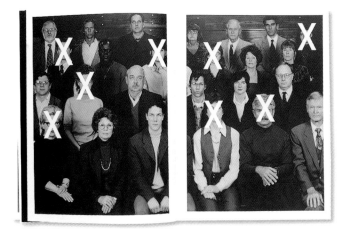

Blurred photos, crossed-out faces and names, and vintage photos represent the statistics a cardiovascular disease research and development company is working to improve.

Illustrated diagrams portray coronary artery blockage, and the treatment process as a time line. Their upward placement on the right-hand page indicates a positive direction.

Silicon Valley Bancshares

Project: Annual report

Design Firm: Cahan & Associates

Art Director: Bill Cahan

Art Director/Designer/Copywriter: Todd Simmons

Photographers: Todd Hido, Jock McDonald

Copywriters: Tim Peters, Jamie McGinley

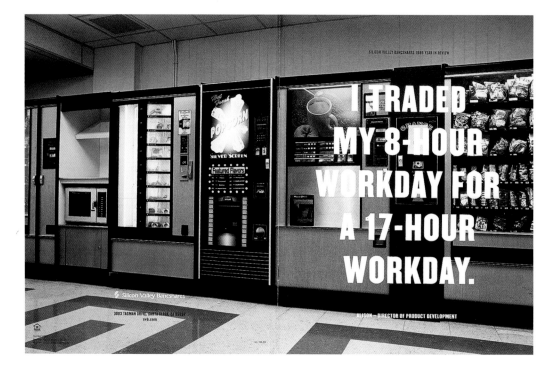

Big, bold statements reverse out of six photos that illustrate realities faced by entrepreneurs. These images appear toward the beginning of an annual report to show the bank's focus on— and understanding of—that type of customer. The slim, forty-page-plus-cover book depicts:

- typical food sources during seventeen-hour days (vending machines extending from front cover to back)
- a portable desk (a trunk view of a car)
- missed commitments (an empty school stage to represent the location of a recital a mom missed)
- an office (hotel meeting room)
- former biggest investors (mom and dad)

Later in the book, readers meet photos of each of the entrepreneurs who faced those realities and succeeded (with, the book implies, the help of their bank).

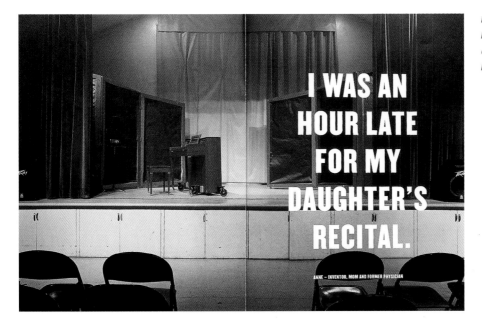

I WAS AN HOUR LATE FOR MY DAUGHTER'S RECITAL.

ANNE – INVENTOR, MOM AND FORMER PHYSICIAN

Photos of life in the fast lane are meant to hit entrepreneurs where they live...and eat and work.

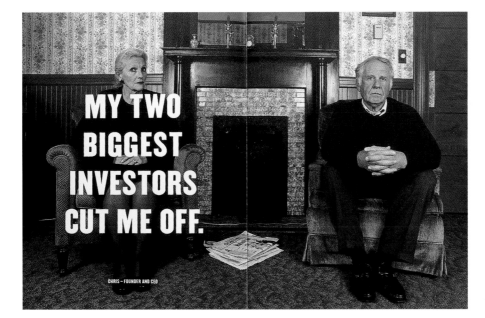

MY TWO BIGGEST INVESTORS CUT ME OFF.

CHRIS – FOUNDER AND CEO

RotoVision

Project: Book cover
Author: Lazar Dzamic
Editor: Natalia Price Cabrera
Art Director/Designer: Slavimir Stojanović/Futro

You wouldn't expect the cover of a book called *No-Copy Advertising* to be filled with type...so it's not. A conspicuously empty speech balloon dominates the bright red page, with the title and author's name in relatively tiny type at the bottom.

The concept wasn't the only one Stojanović came up with for a book that explores the graphics-based ad trend. "First we used a suicidal letter *A* who thought life wasn't worth living without a job. That was funny for sure, but we decided that empty comic-book text balloon worked better. It was more precise and it almost seemed unfinished," similar to the no-copy ads presented in the book. And it's that very "feeling of emptiness" in copyless ads that "makes you search for clues."

Here are two takes on a book cover design... the red one "won."

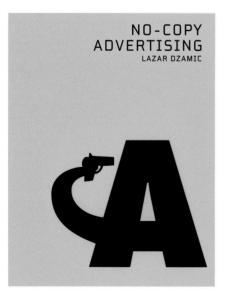

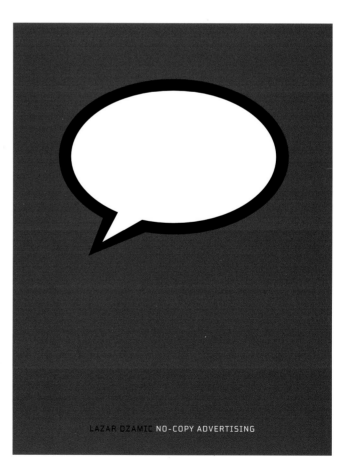

22

World Kitchen Inc.

Project: Packaging
Design Firm: Smart Design
Design Director: Paul Hamburger
Designer: Nao Tamura

Graphics as simple as one, two, three show the process of turning whole herbs or spices into ground ones. The icons, photos, and colors also identify the type of herbs or spices processed by each product.

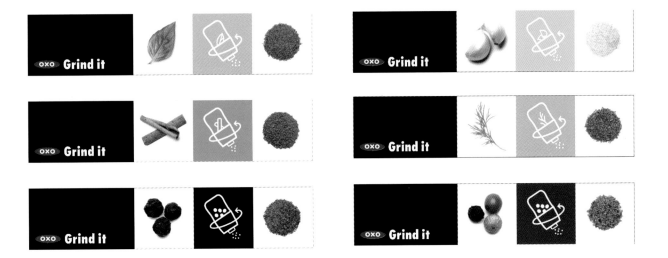

The packaging for OXO's Grind It line of products features iconic drawings to demonstrate the products' uses: to grind up herbs and spices. An arrow encircling each illustrated tool reenacts the rotational movement of the grinders. "The spices that come with the grinders are sorted and packaged into categories of compatible flavors," design director Paul Hamburger said. The packaging is color coded to differentiate the categories, and to create "a kind of paint-by-numbers simplicity."

The colors bear as close a resemblance to the categories as they can, while still creating a pleasing packaging scheme: Red handily refers to peppers, pale mustard-yellow passes for garlic, and green is the only possible choice for basil. The categories also are differentiated by what's shown inside the grinder icons...filled circles to represent peppers, stylized shapes for garlic, for example.

The packages show the entire grinding process in sequential order: A photo of the whole herbs and spices is on the left; the diagram of the grinder in action follows then the results—a photo of a neat circular pile of the freshly ground flavorings.

AMB Property Corporation

Project: Annual report
Design Firm: Cahan & Associates
Art Director: Bill Cahan
Designer: Karin Myint

Words have no place in the first six pages of an industrial real estate firm's annual report. Visually centered on each page is a 2 1/2-inch by 1 1/2-inch (6 cm by 4 cm) black-and-white photo of the same distribution facility. On each page, it's shot at a different time of day, suggested by the time in red at the lower right.

Besides the time check, each photo is identical—empty—until the next to last one, which is filled with products. The next page shows the facility an hour and a half later. It's empty again except for a cart. The punch line appears in tiny type on the facing page: "The ultimate distribution facility is empty most of the time."

The way the company helps is reinforced through other graphics in the book: "Distance divided by time equals speed—and speed is the critical factor in today's competitive environment." Those three elements of the equation are depicted in two-page spread photos of a truck backed into a distribution facility, train tracks, and the cargo hold of an airplane. They graphically link with the small facility photos with the thick, black borders they have in common.

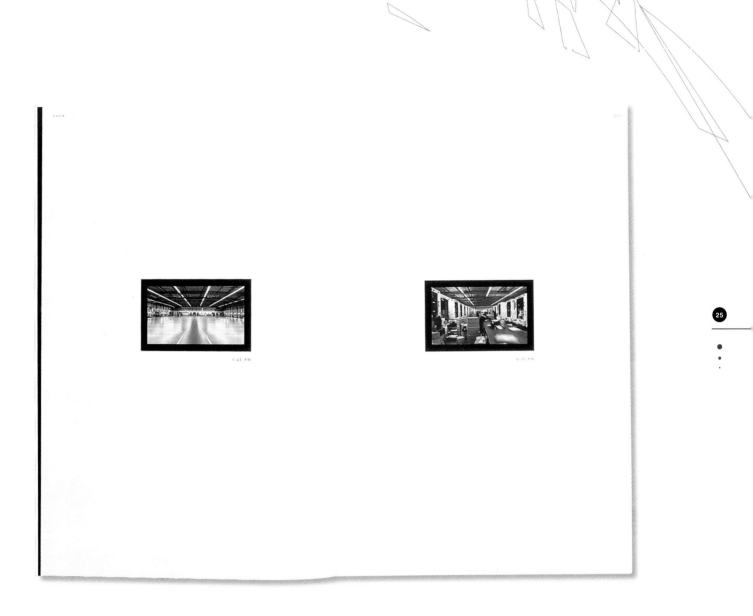

An annual report begins with six pages. six photos of a day in the life of the same space. Except for one of the photos. which shows the space filled up. only the hour changes. The shots demonstrate that the best type of distribution facility is usually empty.

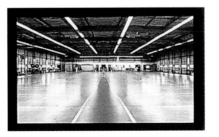

"Hey, stop in your tracks and pay attention to me" is the meta-message of every poster. Destined to be wallflowers, yet forced to speak up for themselves, posters must employ visual clues to communicate even to those passersby who won't slow down, but get the message on the fly, billboard-style.

The poster may appear alone, plastered shoulder-to-shoulder, or even overlapped with others. It may go up outside or inside. If you know this, you can choose the right paper and printing methods—and the right scale of the elements for optimum viewing distance.

Simplicity is key. Fast-talking posters are the result of visual editing; as Michelangelo did with his carvings, the poster designer takes away everything that doesn't contribute to the goal. Posters that rely on graphics speak louder and more quickly than those that specialize in words.

posters and other promotions

Chapter Two

Poster design is a usability task. Attached to the wall, a poster becomes part of the architecture, so you're wise to think about how people will relate to it in architectural terms. At what distance will they view it? Will they be hanging out, sitting near it (in a bus shelter, library or a bar, for example) or are they moving targets (driving past a poster on a storefront)?

Yet regardless of a poster's surroundings the graphic task is the same. First, assume the worst—the least amount of time, attention span, and even motivation on the part of the viewer. Then, choose information graphics that need no words to visually broadcast the message and link directly to the consumer's mind.

Powerful poster graphics—such as the ones you're about to see—demand and earn attention.

Other promotions: For an ad, an invitation, or a brochure the physical context changes. The audience is meant to view it at arm's length or less, as you hold the magazine or newspaper it appears in. An ad has a lot of competition. And it's not as if any reader but a designer is necessarily motivated to look at it. In fact, the reader is probably there to see everything that isn't an ad.

So ads gotta be good. They have to use visual puns, make quick graphic connections, pull no punches. No time to waste. Check out these prime examples.

Project: Ad
Agency: Grey Worldwide Toronto
Creative Director: Marc Stoiber
Art Director: Shelley Weinreb
Copywriter: Christina Angelopoulos

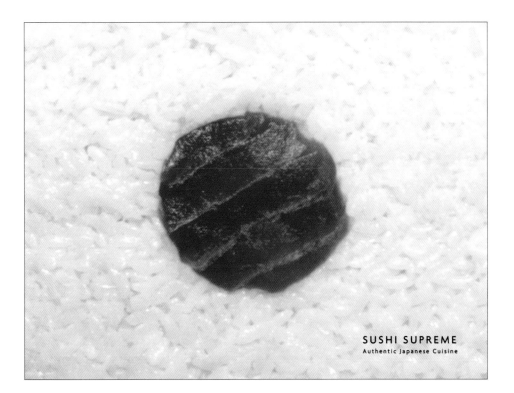

SUSHI SUPREME
Authentic Japanese Cuisine

*A Japanese restaurant sells
the authenticity of its fare
with the Japanese ("land of
the rising sun") flag made
from sushi ingredients.*

Ontario Hemp Alliance (OHA)

Project: Poster
Design Firm: Amoeba Corp.
Designer: Michael Kelar

What hits you when you look at this poster? Maybe it's that all-encompassing green, the orange word, or the flower made from the recycling symbol. Or maybe it's a quick blend of all three. Either way, you're getting the idea even before you notice the other layers of meaning (including two layers of "sell." The poster had to promote a painting exhibit that promotes Canada's hemp industry, so the designer wisely focused on the industry.).

As a focal point, the dimensional recycling logo:

- forms a flower to symbolize growth and new life.
- ties in to the traits of the hemp paper.
- acts as a metaphor to the cycle of life and death, while focusing on rebirth and renewal. Michael Kelar showed the logo evolving (in the screened, horizontal bar) to represent the life cycle in relation to plants. From left to right, the icon decomposes, then renews itself on the far right.

More significance: The orange dot in the center represents the energy or heat needed for growth, and the heart of the flower. The echo effect on the symbol and on some of the type reinforces the idea of recycling. It also adds the feeling of motion and growth to a static image. Now look at the tiny details. A photo of the hemp plant never lets viewers forget who the sponsor is. To keep them from forgetting the nature of the event, subtle illustrations of three paintbrushes appear in the upper right.

The poster's green is brighter than the color typically used to represent the environment. The designer chose the color for its energy and impact, to suggest qualities of the re-emerging hemp industry. Kelar chose the typeface Din for its legibility and compatibility with his vision. "It's not too complex and doesn't take away from the other objects on the page." He found the face was often used in German way-finding systems.

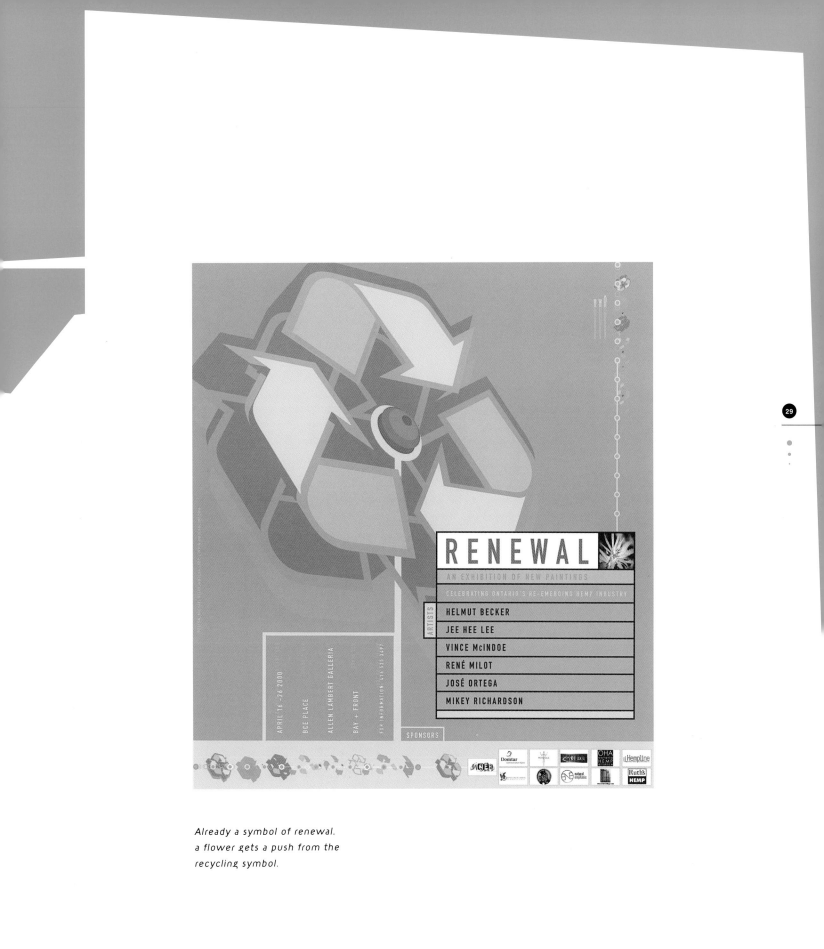

*Already a symbol of renewal.
a flower gets a push from the
recycling symbol.*

Clear Channel Entertainment

Project: Theater marketing tool
Design Firm: Dorr Design Associates, Inc., NYC
Design Director: Cheri Dorr
Designer: Aya Kotake
Photographer: Rivka Katvan
Copywriter: Laura Belgray
Retoucher: Bill Costello

A promotion that looks like "the best seat in the house" gives prospects a feel for the cushy benefits of theater-production sponsorship. This piece opens up like a chair, revealing inserts and a working flashlight tucked into the pouch.

Nothing says "take the best seat in the house" better than…a seat. The sales force for the theatrical division needed a break-through-the-clutter way of attracting high-end corporate partners for various levels of sponsorship: from a wine company to host tastings during intermissions to a large corporate entity to fund renovations.

The plush theater-red "chair" folder and inserts were designed to evoke an immediate emotional and visual response. The intention was to make recipients feel as if a seat in the theater has been reserved for them. It was also meant to evoke the experience and excitement of the theater, including looking for the row with the right number on it and settling into your velvet seat. The velvet look was achieved with PVC plastic wrapped and heatsealed around foamboard for chairlike sponginess. And it's not just any seat. The number plate reads H106, which the designers' research revealed to be considered the best seat in most houses.

30

Although the number plate looks like the actual brass version, it is printed on paper mounted to board, die-cut, and glued on the front cover (the "back" of the "seat"). The package includes tabbed cardstock dividers inserted into corner pockets on the bottom part of the seat. They're printed in four-color, plus a metallic and gold-foil stamp. The top sheet includes a graphic of a ticket in gold over a close-up photo of plush, red theater seats. Other dividers feature candid-looking close-ups of backstage and onstage photos. The backs of the dividers reinforce the message in elegant script dropped out of metallic green ink.

Gold and burgundy letterhead is included to be used for personalized marketing letters and for printing out the PowerPoint presentation that accompanies the delivery of the package. The final touch: the package also includes a 3-inch by 3 $\frac{1}{2}$-inch flat working flashlight printed with the chair and number-plate graphics to help recipients "find their seats."

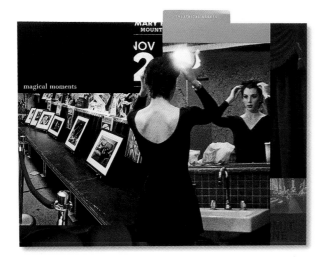
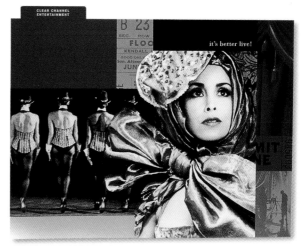

The photographic inserts carry the theme effectively to two dimensions.

Sayles Graphic Design

Project: Fund-raising poster series
Designers: John Sayles, Som Inthalangsy
Illustrator: John Sayles

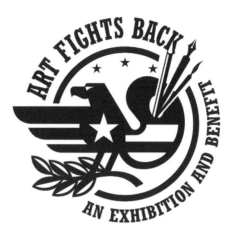

The logo for the series takes an appropriately patriotic tone. with a WPA style.

John Sayles turned his horror at the terrorist attacks against the United States on September 11, 2001, into a series of thirty posters called "Art Fights Back." Sayles drew his inspiration—both for the project and the graphic style—from the World War II–era posters of the Works Progress Administration (WPA) of the 1930s. The modern series also drew upon the original's call-to-action, unifying mission. The posters printed as 6- and 9-foot banners for the opening of the poster exhibition three months after the attacks.

Although the posters all succeed as powerful images, a few speak most expressively as information graphics. Take the image Uncle Sam with a black eye. That concept came directly from a quote on CNN on the day of the attacks. An official said the attacks constituted a black eye on the United States. "Right," said Sayles, "In the big scheme of things, the terrorists 'didn't chop off our head, or take a limb.' They gave us a black eye and now we're pissed." The United States iconic character came to mind, then "what if I just gave him a black eye?" Despite the shiner, Uncle Sam's facial expression remains determined and optimistic.

Another U.S. icon, the eagle, is also used for the poster series' logo. One of its wings is an artist's palette, with a paintbrush, pen, and art knife (now we're really talking the 1930s) held in its thumbhole.

"Only Cowards Kill and Hide" combines WPA and almost comic-book styles. The viewer's perspective comes from above the Twin Towers, as if to suggest the morally superior position to the red hand reaching from below. "I wanted to put us on a higher level, in the sky, looking down, with the red devil reaching up," Sayles said. Osama bin Laden's head in caricature forms the *o* in "cowards." A threatening-looking dagger forms the diagonal part of the *r*.

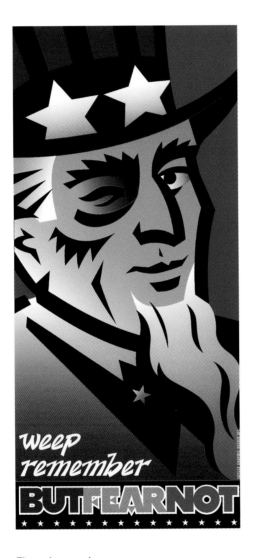

These two posters are part of a fund-raising series that responded to the unthinkable.

Creative Time, Antenna Design-New York

Project: Brochure
Design Firm: Org, Inc.
Designer: David Reinfurt

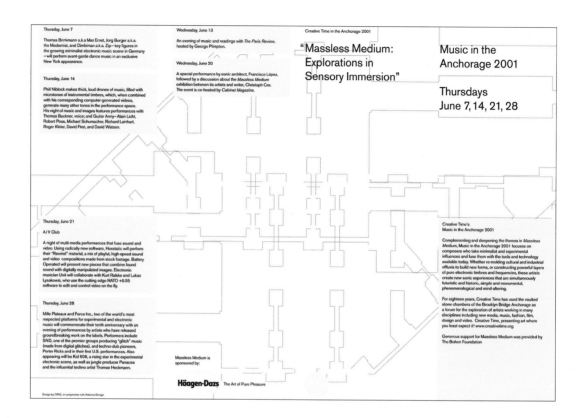

For David Reinfurt, principle of Org, making the invisible visible drives much of his design process. From the selection of typefaces that quietly allude to past printed materials and the use of a white box to denote the work of a sound artist, Reinfurt's work communicates through intense, but subtle, intelligence. Beyond this, he believes in presenting his clients with one solution; he would rather rework a single concept than develop a new one for each client, and he prefers to work solo.

When Creative Time, an organization that presents exploratory art in unexpected venues, asked Org to develop a brochure for a series of technically advanced, mixed-media events, to be held in the Brooklyn Bridge Anchorage, their only suggestion was the use of a map. The challenge for Reinfurt was how to convey a sense of newness and edginess, while clearly communicating the requisite information about the event, its fourteen participants, and its historic site.

With the concept of a map in mind, Reinfurt chose the floor plan of the Brooklyn Bridge Anchorage as his point of departure. He continued to experiment by adding two more layers of the floor plan, which he flipped, rotated, and assigned different colors (cyan, magenta, and yellow). Not content with this traditional palette, Reinfurt replaced the C, M, and Y with fluorescent equivalents. (He is eager to point out the barely visible patches of green and purple that occur at the intersection of the differently colored lines.) The resultant image, which appears on the opening side of the brochure, is at once recognizable as a floor plan, yet new and engaging—a cross between computer chip circuitry and a subway map.

Juxtaposed to the openness and random quality of this image, the flip side of the brochure is a deliberate study in Mondrianlike precision. But, through an interesting distribution of the colored text boxes and the ample use of white that helps to define the grid, the images obtain a kind of structured randomness that plays off the Anchorage floor plan on the obverse side of the brochure. Though not planned, the detail Reinfurt likes best about this project is the empty, white box above the information for the artist who designs with sound—the invisible made visible.

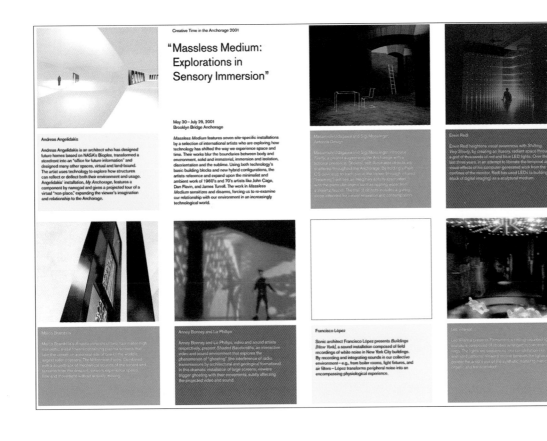

Theater Grottesco

Project: Poster
Design Firm: Chermayeff & Geismar, Inc.
Designer: Ivan Chermayeff

You hear the name Theater Grottesco and already you know there's attitude going on. So when the repertory company in Santa Fe, New Mexico, asked Ivan Chermayeff to design a poster, he wanted it to "act as a visual souvenir of the performance as much as to remind the Santa Fe audience of the attitude and quality of the theater group." He describes the attitude as "diverse" and "contemporary."

Chermayeff's poster depicts a play that's a "theatrical collage of style, which is why we thought of Ivan" (who is known for his poster collages), said John Flax, artistic director of the company.

"On one level, the evocative images that form a man's head embody the theater group. For example, the 'lips,' arms in the place of legs, convey the group's boldness and sexiness," Chermayeff wrote. The Native American baby (acting as the left nostril) represents the cultural surroundings of Santa Fe.

On a deeper level, the image reflects the play's emotional themes. It looks offbeat and intriguing to people who haven't seen the play. For those who have seen it, the poster's symbols open up like the secrets revealed behind the gradually opening "doors" of an Advent calendar.

Flax anticipated that the complicated performance would pose a poster-design challenge. "We thought 'what's the graphic for this?' I sent Ivan as many notes and pictures as possible. I even saved my to-do checklists and sent those. He sent them back, thinking I'd made a mistake!"

Flax explains the play to illustrate the design challenge and the poster's deeper meanings: It's a love story about two people who don't know they're in love for most of the play. After the man is laid off from the corporation where they both work, he spends most of his time in malls. The woman, meanwhile, gets promoted and overworks until she drops from a heart attack. While she convalesces, she goes to the mall where she chokes on a piece of popcorn. The man turns up to help and they do a repetitive dance—his interpretation of the Heimlich maneuver he has seen only on television.

The theatrical theme is being out of touch with feelings. It's a portrait of the disassociation rampant in present-day America. You can see that theme reflected in the images: All the facial features are "off," so the senses don't work. Let's look again at the arms used as legs that form the mouth. "It's wonderful as a mouth because it's so disturbing," Flax said.

The left "eye," a photo from the performance, represents the dancers, looking away from each other, and stiff. The right "eye" is a target, an image that's so often used to represent getting it right; you have to look twice to notice that in this one, every shot hits off the mark.

There's a real eye, but it's an animal's, and it too is rendered useless because of its position as the right nostril. The clouds as the nose reinforce the lack of clarity. Only the ears look close to functional, but the tiny openings suggest diminished hearing ability.

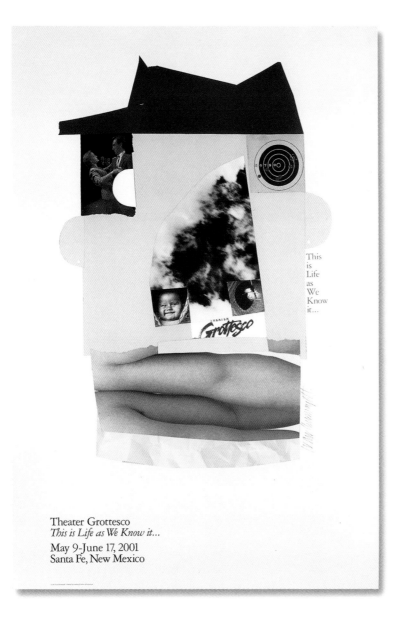

Theater Grottesco
This is Life as We Know it...
May 9–June 17, 2001
Santa Fe, New Mexico

Unsensing features fill the face of a play's pathetic hero. They depict his disassociation with them and the world around him.

AIGA

Project: Design conference invitation
Design Firm: James Victore, Inc.
Designer: James Victore

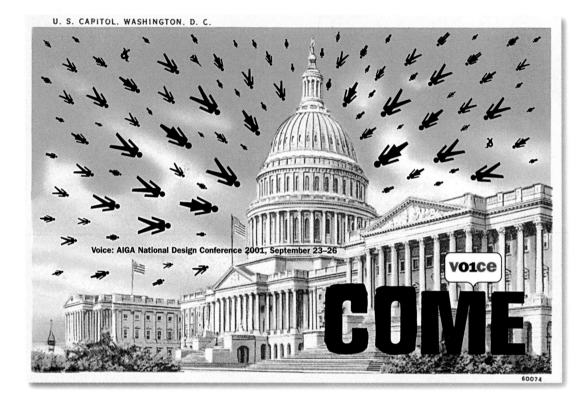

Given less than one week to create an invitation for the AIGA National Design Conference 2001, to be held in Washington, D.C., graphic designer James Victore did not have the luxury of producing multiple comps and making numerous revisions. "When I received the assignment, I immediately pictured the United States Capitol building and began rummaging through my collection of photographs and postcards," says Victore. "Thanks to an aunt in New Jersey, I had just the postcard that I was looking for."

Next, he envisioned the conference participants flying in from any number of locations and decided to give the phrase "flying in" a more literal bent by placing images of people flying towards the Capitol building. And, what images could be more appropriate than those found on the doors of public restrooms around the world?—design at its most generic yet most recognizable. "Initially, I put one or two of the little restroom symbols on the invitation," explains Victore. "Then I began thinking about who else should be represented: women, men, the physically challenged, cross-dressers, and the number of figures just multiplied."

As for the hand-rendered lettering on the front and back of the invitation, Victore had intended to replace it with Franklin Gothic. But, in keeping with spirit of the conference and the concept of the postcard, he decided to leave the hand lettering in place. "By using a postcard as the vehicle for the invitation, I also managed to convey that time-honored travel sentiment, 'Wish you were here.'"

Duracell

Project: Ad

Agency: Arih Advertising Agency

Art Director/Designer/Copywriter:
Slavimir Stojanović/Futro

Photographer: Aloša Rebolj

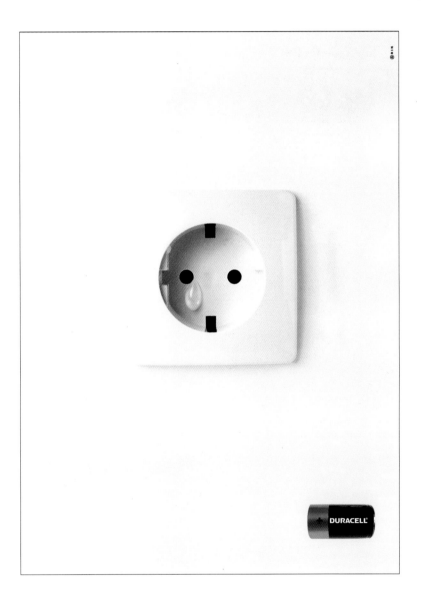

Unlike Theater Grottesco's emotionally disconnected piece (see page 37). an empty electrical outlet finds itself thoroughly in touch with its feelings. The outlet represents electricity that's overlooked in favor of battery power. The teardrop falling from the "eye" of the "face" in the outlet suggests a long-lasting absence.

GlaxoSmithKline

Project: Ad
Agency: Grey Worldwide Toronto
Creative Director: Marc Stoiber
Art Director: Shawn McClenny

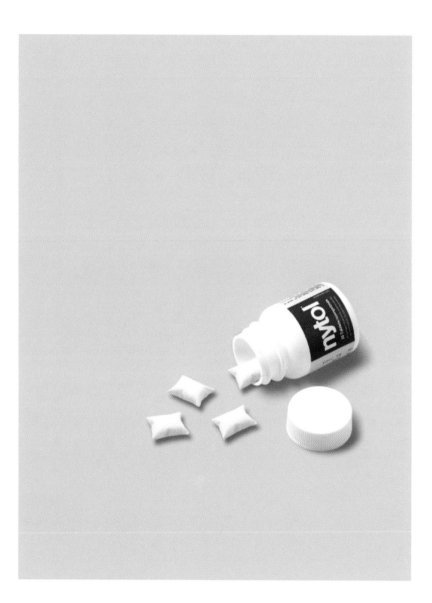

*Pillows instead of pills tumble
from a product that is used to
aid sleeplessness.*

HBO

Project: Poster
Agency: Dieste Harmel & Partners
Executive Creative Director: Aldo Quevedo
Creative Director: Carlos Tourne
Art Director: Jaime Andrade
Copywriter: Alex Duplan

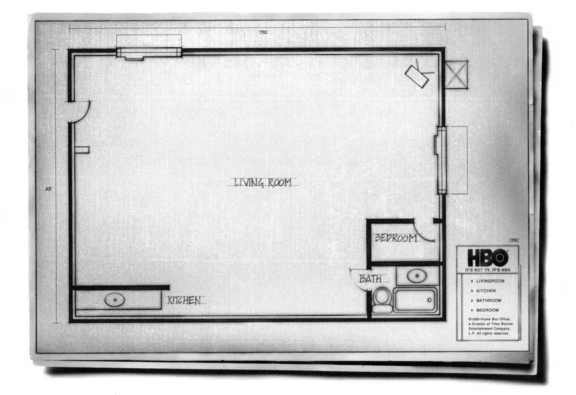

In this poster for the cable-TV
network, a "typical" subscriber's
apartment blueprint puts the
emphasis on the TV room, with
the other rooms looking like
nonessentials in comparison.

Writers' Theatre

Project: Poster

Design Firm: Lowercase, Inc.

On the surface. a couple (solidly) turns away from each other. but they're really drawn to each other (in outline form). That's a visual reference to the play the image promotes.

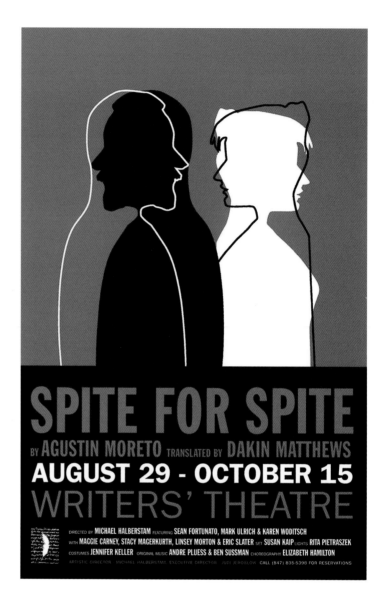

Every promotion for a suburban Chicago theater employs a play-related visual element that incorporates a subtle trick. For example, a black profile of a man and white profile of a woman stand back to back on a promotion for a play called *Spite for Spite.* An outline of the figure overprints in reverse to show them facing each other and to represent their secret attraction.

The graphics form a visual synopsis of the play: Two members of the Spanish nobility hide their romantic interest in each other. When one shows even a bit of interest, the other turns away; then they switch, engaging in a kind of dance.

Kriz Public Library

Project: Poster
Design Firm: Cavarpayer
Art Directors/Designers: Ira Payer, Lana Cavar

To announce its 115th anniversary, a public library in a small Croatian town commissioned a poster. Books are the obvious image of choice for such a project, but Ira Payer and Lana Cavar took a different perspective on the common theme. "We photographed an entire shelf with the collection of Shakespeare's works published at the end of the nineteenth century, but from the other side." The result could be any books, as long as they're old and classic looking, and viewers can guess that their vintage matches that of the library.

The books print actual size on the poster, designed to display horizontally or vertically... or in multiples, lengthwise, or stacked, as in a library. In fact, the organizers of an anniversary cultural event covered the town with them, in effect turning the town into a library.

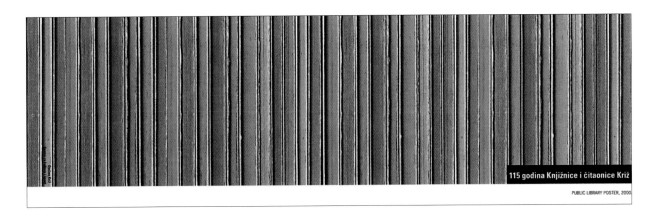

115 godina Knjižnice i čitaonice Križ

PUBLIC LIBRARY POSTER, 2000

*That's a rare view of rare books.
shot to celebrate the 115th
anniversary. and to suggest the
vintage of a Croatian public library.*

Scena Kod Vuka Theater

Project: Poster
Photographer: Vuk Velicković
Art Director/Designer: Slavimir Stojanović

Graphically. two empty chairs—suitable for any waiting room—symbolize the people who normally wait in them as much as the chairs appear to wait to be filled. Typographically. the title of the play waits to be completed by a wayward t.

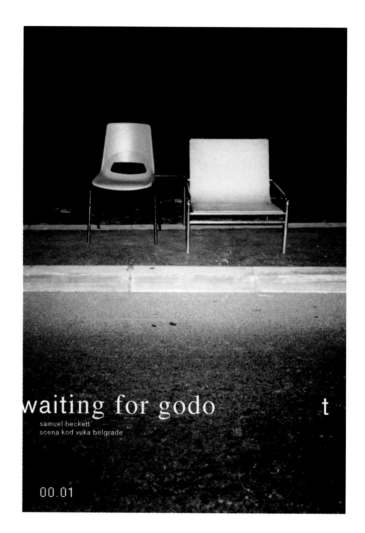

For a poster to promote Samuel Beckett's play *Waiting for Godot,* the art director used an image of two mismatched, empty chairs on the sidewalk "as a symbol of everlasting waiting." Slavimir Stojanović continues: "A much bigger problem was the headline. Nothing seemed appropriate. I realized I would have to imply waiting in the typography itself. While I was playing around with Helvetica and Times, the letter *t* got tired of waiting and went away, which gave the poster the needed visual action to convey the desired emotion."

Oliver Belopeta/Skopje Jazz Festival

Project: Poster
Art Director/Designer: Slavimir Stojanović/Futro

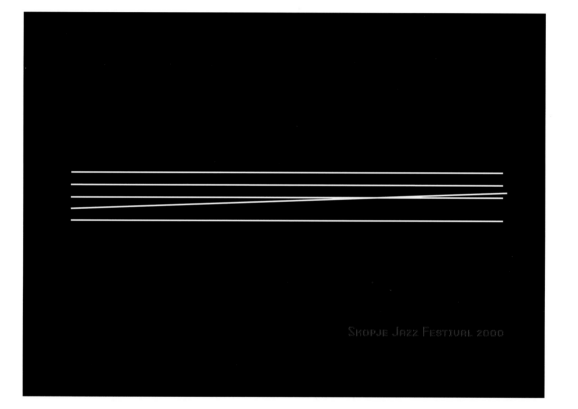

*For a jazz festival's poster,
one skewed line on a reversed
musical-note chart shows how
jazz is different from other music.*

Southern California Institute of Architecture

Project: Poster/postcard
Design Firm: 88 Phases
Creative Director: Daniel H. Tsai
Designers: Daniel H. Tsai, Luis Jaime, Wolfgang von Geram

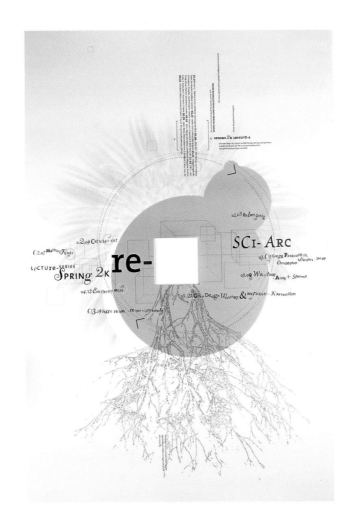

Flowers, roots, arrows, circular cyclical patterns and a well-placed die-cut square explain re-, the name of a series of architecture school lectures.

The Latin prefix *re-*, as in rethink, regrowth, reinvent, redefine, recontextualize, was the name of an architectural school's lecture series. With the prefix meaning, "to do again," the designers of the series poster and postcard "played with the notion of everything coming full circle" and starting again, Luis Jaime said.

So the designers arranged speakers' names and speech dates in a clockwise rotation around a central die-cut square. Simple red angles act as arrows to clarify the cycle's direction and the sequence of the numbered lectures. Although numbers print in red ink, they're tiny, depending for visibility on yellow outline circles around them and the dates. A graphic of a flower and roots plays up the cyclical nature of the series and its theme. Subtle diagrammatic squares, cubes, and lines reinforce the architectural context of the series.

If you look for the rationale behind the square die-cut, you may hit a brick wall—or concrete, or even mahogany. The rationale is the architecture: the designers wanted "to give the viewers the ability to recontextualize for themselves." So in effect, the poster will change depending on where it hangs. And with the square placed just after *re-*, the positioning opens almost limitless possibilities for filling in the blank.

In keeping with the theme, the designers even "recycled" the pieces cut to make the squares by building in their reuse. They designed the squares as signs to be placed throughout the campus to point toward the lectures.

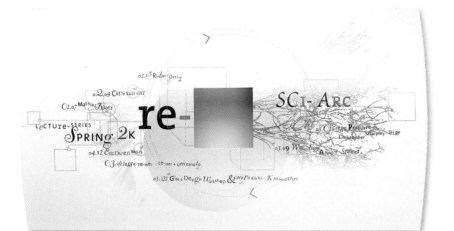

On the back of the postcard, re- isn't die-cut, but it kind of looks that way. It prints backwards and in the exact position of the prefix on the other side of the card, the way it would look if you could see through the card.

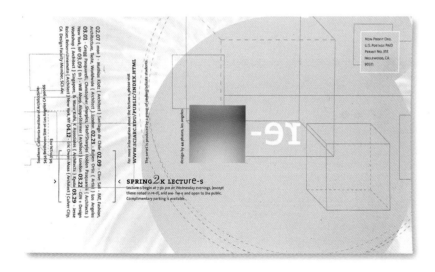

Villas Trsje

Project: Brochure
Design Firm: Cavarpayer
Designer/Illustrator: Narcisa Vukojević
Designers: Ira Payer, Lana Cavar

*Prospects to buy a new town
villa were invited to turn over
a new leaf...and another and
another. on a brochure that
used a close-up illustration
of a leaf as a map. and a base
for floor plans.*

The developer of new town villas in Zagreb, Croatia, asked
Cavarpayer to create a brochure that emphasizes the bond
between architecture and environment. The requested bond went
beyond marketing: The villas along with a new orchard and vine-
yard would be built on the site of old vineyards.

The cheerful coexistence of habitat with nature was expressed on
every page. It starts on the cover, where a realistic close-up illus-
tration of a leaf serves as a map. The veins become streets, with
dashed lines to show the relative distance between the villas and
the town.

Inside the brochure, three white boxes that represent the three villas
rest on the leaf close-up and abut a big section of illustrations of
orange autumn leaves against green ones. On pages that follow,
floor plans on the leaf close-up fill with illustrations of fruit to reflect
the orchard neighbor to come.

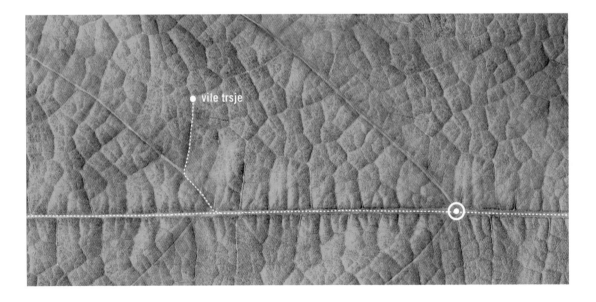

Fruit in the floor plans conveyed the site's past and future orchards.

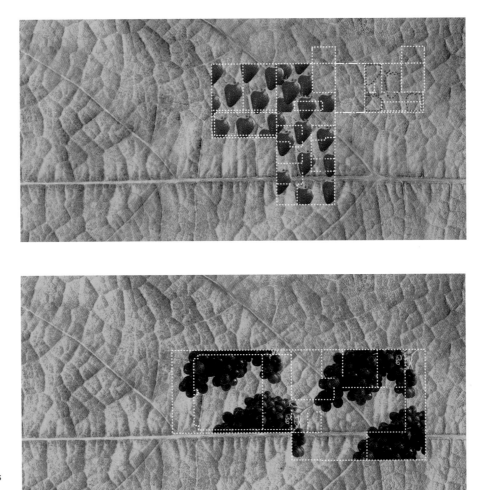

A pop-up on the envelope lets recipients see the villas emerge from the woods.

Another page shows representations of windows in the plans, to help boast of the view. Viewers know they're windows because the rectangles contain varying illustrations of blue skies.

The pages are perforated and contain brief descriptions and a map or a detailed floor plan on the back so they can be sent as picture postcards. The brochure arrives in a pocket-folder envelope that folds out to a pop-up of the villa on the same leaf graphic.

MDB Communications, Inc.

Project: Anniversary campaign
Creative Director: David Page
Senior Art Director: Julie Kundhi

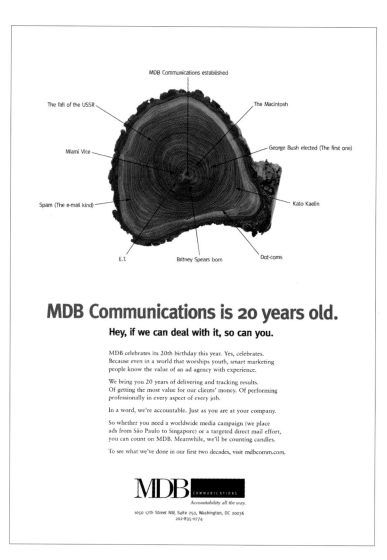

It's often nature that supplies the most universally understood images. So to announce the agency's twentieth anniversary in business, MDB found a symbol that was made in the shade (or at least one that *makes* shade). An aerial view of a cross-sectional tree slice boasts its rings—an instantly recognized symbol of growth and age.

Using the image in the context of an anniversary, the agency sought to demonstrate more than its age. The tree rings also suggest experience, health, growth potential, and an ability to weather storms. As a diagram, the image says even more: strategically placed call-outs point out various events—from the profound to the trivial—that have taken place in the years since the firm's founding.

The diagram translated to a print ad, a large-format lobby display, and a Flash-based animation on the agency's Web site.

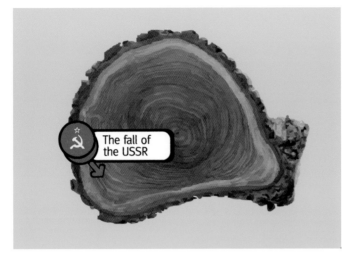

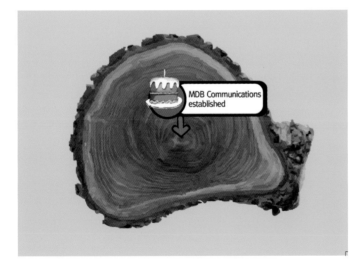

Perhaps not since
The Wizard of Oz has a
tree communicated so
much. This slice conveys
experience, success, and
twenty years in business.

Environmental Literacy Council

Project: Poster
Design Firm: OmniStudio Inc.
Designer: Lynne Smyers

Eyes and the Earth show up frequently in graphics. In this poster, for a nonprofit organization that promotes awareness of the physical world, designer Lynne Smyers used the play on words and images to convey that awareness. She wanted to do so provocatively, yet simply enough to be understood by the group's diverse audience, from K–12 students to college professors.

The iris/earth combination was conceived to work on at least two levels: it literally supports the tagline, "See Your World," while it explores the complexity of nature. By reducing the size of the Earth to the size of an enlarged eye, the designer communicated the accessibility of the Earth.

The designer didn't consider any graphic alternatives, because "this felt like 'Design Nirvana.'" When that happens, Smyers said, it doesn't take much effort to convince the client.

You'll notice two different typefaces: The logo is set in Bauer Text Initials; the poster type is Augustea. The type choices reflect the designer's intention for the two pieces to be independent of each other, but to have a similar feeling. They also reflect the client's desire for more polish than the more "homegrown" Papyrus type of the original logo. To Smyers, "it had start-up/grassroots written all over it. I tend to lean toward classic, elegant fonts."

The Earth in place of a pupil
makes it easy to "see your
world" in this promotion
for an environmental group.

AIR · ECONOMICS · WATER
FORESTS · SEE · BIODIVERSITY

YOUR · ENERGY · WASTE · FOOD
CLIMATE · POPULATION · WORLD

ENVIRONMENTAL
LITERACY COUNCIL

Whitney Group

Project: Brochure
Design Firm: Thirst
Designers: Rick Valicenti, Ewa Sarnacka
Photographer/Digital Retoucher: Richard Paul
Copywriter: Rob Wittig

The goal of a brochure for CEO headhunters was to convey searching power that has no boundaries. The message of endless space begins on the front cover, with only the word "search" at the base of an otherwise black ground. The designers liked its simplicity and the feeling of suspense it created as recipients open the book. They chose the colors to match the somber-suited attire of the high-ranking executives who would receive the brochure. Outer-space imagery reinforced the idea that the company's reach is limitless.

On an inside spread, colorful pixelated "route" paths on the pixelated Earth signify people...one for each pixel. The image represents the art of finding the perfect person for the job.

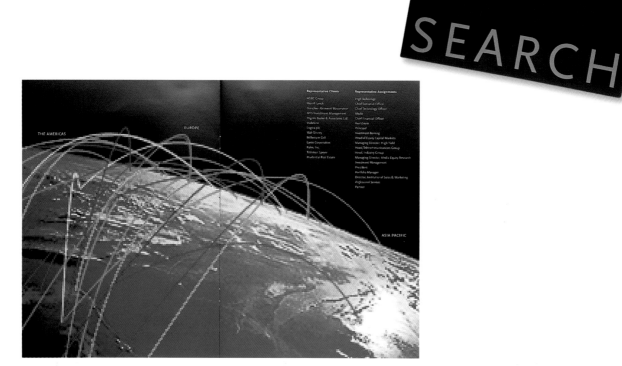

The designers chose the brightest of the path colors for the backgrounds on the spreads between artwork. Color spreads separating dark ones impose visual pacing. Those and the brevity of the book are meant to keep readers turning to see what's on the next page.

The bar over the *W* in Whitney is the company's trademark, so the designers extended it through the book by using it over any powerful phrase that has a *w* in it, as a reminder of the company name.

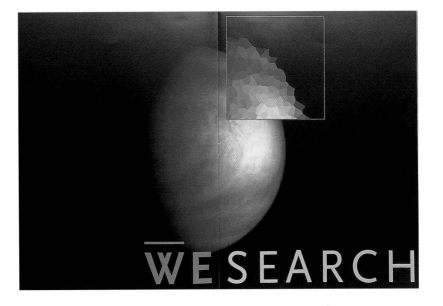

The idea of a firm that searches the world and beyond comes across with vast black fields and global graphics with close-ups and paths made of pixels.

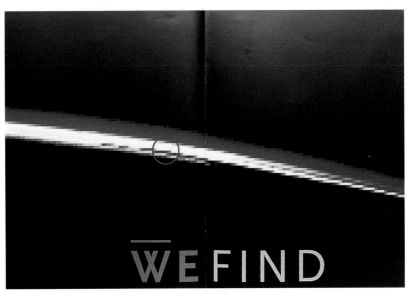

AIGA

Project: Poster
Design Firm: Doyle Partners

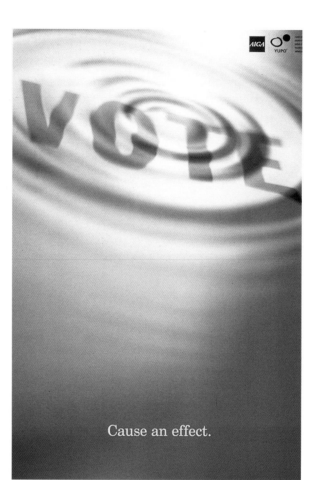

Cause an effect.

Ripples emanating from a pebble tossed in a lake with letters superimposed illustrate the effect of a single vote. It's a poster for AIGA's "Get Out the Vote" campaign that targeted U.S. citizens. The suspense-filled 2000 U.S. presidential election inspired the theme.

Ontario Lung Association

Project: Ad
Agency: Grey Worldwide Toronto
Creative Director: Marc Stoiber
Art Director: Alex Beker
Copywriter: Charlene Butler

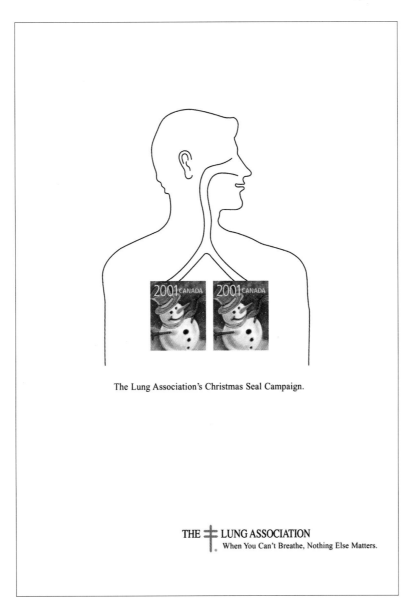

The Lung Association's Christmas Seal Campaign.

THE ✝ LUNG ASSOCIATION
When You Can't Breathe, Nothing Else Matters.

Christmas Seal stamps replace lungs connected to human breathing passages on a diagram. The illustration is intended to inform people that the stamps support the lung association.

Burton Snowboards

Project: Logos/posters
Design Firm: Interrobang Design Collaborative
Designer: Lisa Taft Sylvester

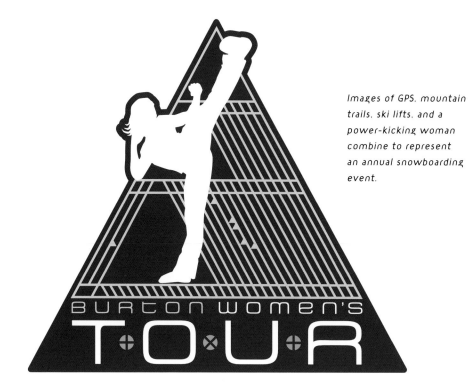

Images of GPS. mountain trails. ski lifts. and a power-kicking woman combine to represent an annual snowboarding event.

A manufacturer of snowboard equipment and clothing holds a promotional sporting event every winter. The logo for the women's event has always had a 'Girls Kick Ass' slant to it." In winter 2001–2002, designer Lisa Taft Sylvester picked up the previous year's Karate Kick Girl logo and merged it with symbols of GPS (global positioning system). The GPS references reflect the event's global nature and the growing association of the tech-nology with extreme outdoor sports.

The design elements tell the story, with a simple triangle for a mountain filled with repetitive diagonal lines (trails or chairlift routes) punctuated by smaller, solid triangles. The triangles suggest travel destinations as well as chairs on a chairlift. The crossed circles and arrows derive from GPS.

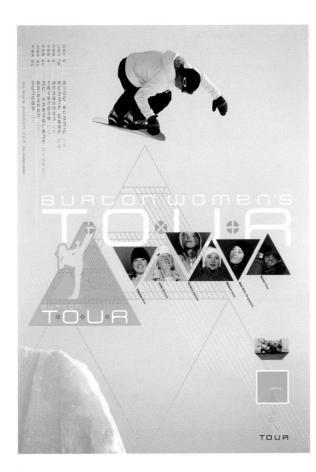

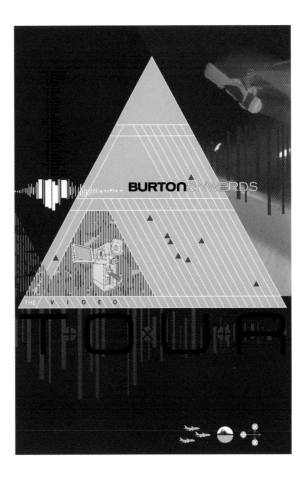

On another poster in the series for
the video tour event. GPS iconography
is more pronounced. along with.
appropriately. a video camera. The
flying snowboard is meant to serve
as an enticing example of the tricks
captured on video.

Springfield Symphony

Project: Poster
Design Firm: The Marlin Company
Art Director: Steve Krone
Concept: Judith Garson

*The image says winter,
holidays, music, and dance.
And the viewer gets it in
one glance. More subtly,
family entertainment comes
across in the childlike
paper-cut technique. Most
subtle is the theater clue:
Graphics beyond the horns
use three small curves to
draw masks, alternating
comedy and tragedy.*

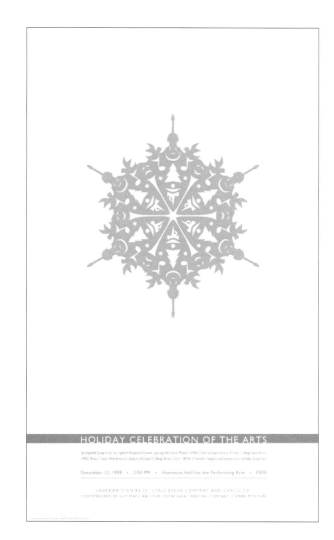

Facing typical client constraints of no time and no money and a call to promote a holiday family performance of opera, dance, symphony, and theatre groups, the designer cut to the chase...with scissors. Mentally traveling back to age five, copywriter Judith Garson recalled when first she unfolded a cutout snowflake. Easier to recall than to re-create: "We finally figured out how to fold the paper and snipped away."

From far away, the playful image looks like the child's snowflake that inspired it. At this remove, you see the first part of the multilayered visual message: winter and family. Come closer, and the message expands to holidays, music, and dance as these components emerge: holiday trees, horns, stars, violins, dancers, and doves nesting on musical notes. Come closer still, and the theater aspect kicks in as you begin to notice alternating comedy and tragedy masks (at the audio ends of the horns that form the central star).

Art director Steve Krone digitally finished the cut-paper effect, and printed the poster in two metallic inks, light blue and silver, on 16-inch by 26-inch white matte-coated stock for a crisp, wintry look.

Project: Ads, posters, postcards for art exhibitions
Design Firm: Tim Kenney Marketing Partners

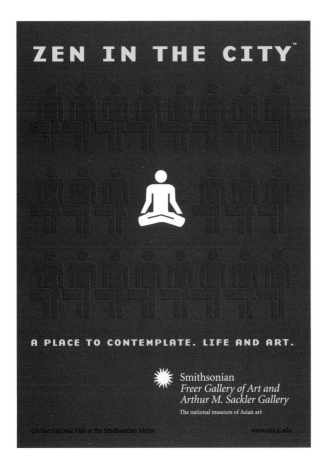

Print messages for bus shelters, postcards, and newspaper ads have to fight for attention in visually noisy environments. So simplicity was essential for images to promote an art exhibition at two of Washington's Smithsonian galleries. This was especially true for the galleries' sophisticated target audience.

The answer: A simple graphic shows a small army of typical busy downtown Washingtonians. All navy blue, practically Washington, DC's uniform, the worker bees have the look of international symbols. They come in just two "flavors": male and female, depicted by slacks or skirts, as is traditional. Each holds the obligatory briefcase in the right hand. They're lined up in military fashion against a bright tomato-red background.

In the center of all these hard-driving folks sits a person representing "Zen in the City"; an oasis of calm. The person looks similar to "his" neighbors, except for color, size, posture, and acces-sory. He drops out of the background to paper white, perhaps to suggest temporarily dropping out of the rat race. He's slightly bigger than the blue figures, to help form the focal point and to suggest a bigger spirit. And he sits in a meditative yoga pose, without the briefcase that appears attached to those around him.

The Partners' Film Company

Project: Promotion
Design Firm: Blok Design
Creative Director/Designer: Vanessa Eckstein

Carrying the table of elements idea a few steps further, Vanessa Eckstein used it in a promotion for a film company. The idea is that directors are elements that, when "combined with the needs of the client, will ignite creativity." Each director, cameraman (the company's preferred term), and partner is identified and shown by name, role, and country as an element formed by his or her initials. Like chemical elements, the initials are set in upper- and lowercase.

The placement of the elements sorts and structures information on many levels, making it easy for readers to grasp. That's the Canadian team on the left; U.S. crew on the right. Numbers and other symbols guide viewers further. A big outline number makes it clear that the fifteen Canadian directors fill the first row of elements and part of the second.

The numbers one through seven that print above "director/cameraman," along with corresponding numbers over each of those elements, indicate that people with that job fill out the second row and the third. In the fourth, see the names of the six partners, signaled by another big outline number and by a tall curved bracket pointing to the job title and encompassing the square.

The information also sorts alphabetically, within categories (except for the Canadian partners). Sequence is based on last names, the second, lowercase initial in each element.

Recipients start getting the theme as soon as they get the promo. The piece arrived rolled up in actual lab glass...a 10-inch test tube. Another nice touch: The recipient's name is embossed, in old-fashioned Dymo label style, on an aluminum band at the tube's opening.

Eckstein printed the one-color insert on old-style blueprint paper to add the idea of building design from the ground up, as film directors do. You know the paper is authentic because it's so brittle it holds the curl even after release from the tube. Another possible level of meaning: retro elements, like the style of the debossing and the blueprints, often communicate a quality of service that is reminiscent of bygone days.

A periodic table of elements
introduces a film company's
artists as essential elements.
The table approach also classifies
them by country and job title.

Onoe Ryu Dance Company

Project: Program booklet
Design Firm: JDG Communications, Inc.
Designers: Tom Gamertsfelder, Sung Hee Kim

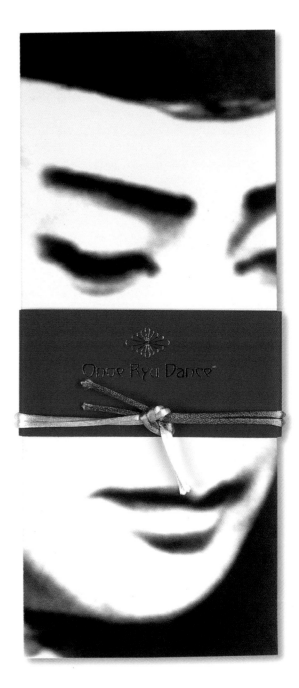

The bands around a booklet that promotes a dance performance at the Embassy of Japan give the first hints at the booklet's purpose. The red, metallic-gold-stamped paper band is almost literally a bellyband.
Gold and white silk intertwined cords encircle it, to symbolize an obi, a sash worn around the waists of the dancers' kimonos. Like the sashes that inspired them, the booklet's silk obis were painstakingly tied by hand...700 of them.

The recipient removes the bands to open the booklet, made of accordion-folded pages that suggest the screen panels used as performance backdrops.

The designers extended the work of the troupe's symbol, a chrysanthemum. It's stylized as the logo and simplified even more as a mark between sections of text. It's also made into a pattern on the inside back cover of the booklet and on the reverse side of the red band. The dance troupe chose the chrysanthemum as its symbol because it is the floral emblem of the Imperial family of Japan, said designer Sung Hee Kim.

Life-sized, black-and-white close-ups of dancers' faces fill the cover and most of the left-hand pages. Tightly cropped and deliberately out of focus, they're meant to show the intensity and movement of the dance. The designers chose the typeface family, Mrs. Eaves, for its elegance and grace, and leaned toward italics to mimic the gentle movements of the dance.

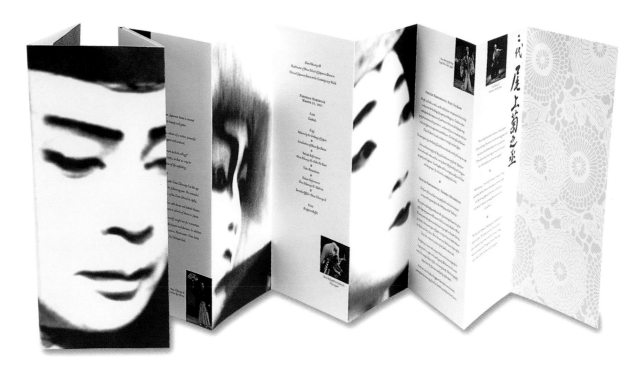

Like an obi, a sash tied around a kimono, a silk sash over a red paper band encircles and binds a booklet for a Japanese dance company.

American Academy of Orthopedic Surgeons

Project: Ad campaign

Agency: August, Lang & Husak, Inc.

Photographer: Liquid Pictures

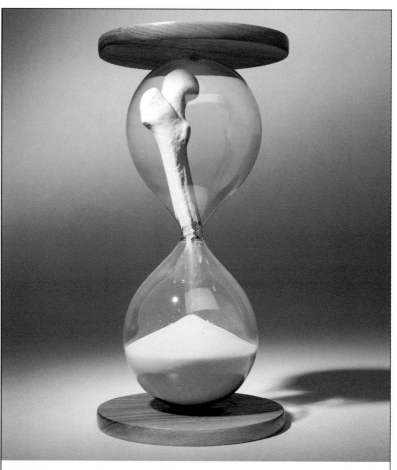

Will your bones live as long as you do?

Osteoporosis threatens 28 million American men and women, causing their bones to deteriorate and weaken. The scary part is, the disease can develop unnoticed over many years — so the time to prevent it is now. Include an abundance of calcium and vitamin D in your diet. Avoid smoking and excessive alcohol use. And perform weight-bearing exercises like walking, jogging or dancing, every day. To learn more, call1-800-824-BONES, visit www.aaos.org, or visit www.nof.org.

American Academy of Orthopaedic Surgeons
We keep you well connected.

Bones are the subjects and sometimes the stars of ads that promote bone health.

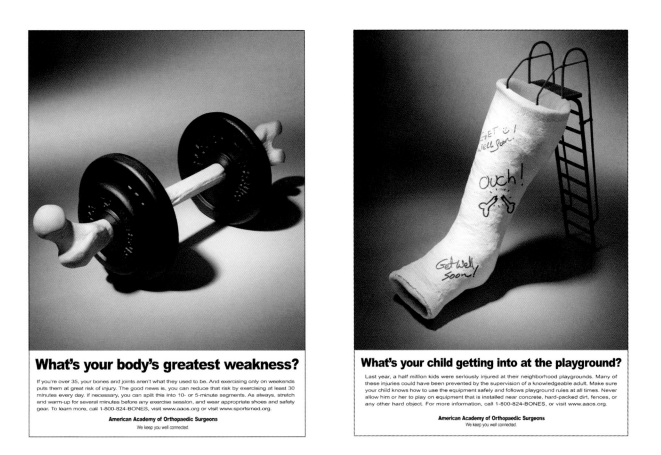

What's your body's greatest weakness?

If you're over 35, your bones and joints aren't what they used to be. And exercising only on weekends puts them at great risk of injury. The good news is, you can reduce that risk by exercising at least 30 minutes every day. If necessary, you can split this into 10- or 5-minute segments. As always, stretch and warm-up for several minutes before any exercise session, and wear appropriate shoes and safety gear. To learn more, call 1-800-824-BONES, visit www.aaos.org or visit www.sportsmed.org.

American Academy of Orthopaedic Surgeons

We keep you well connected.

What's your child getting into at the playground?

Last year, a half million kids were seriously injured at their neighborhood playgrounds. Many of these injuries could have been prevented by the supervision of a knowledgeable adult. Make sure your child knows how to use the equipment safely and follows playground rules at all times. Never allow him or her to play on equipment that is installed near concrete, hard-packed dirt, fences, or any other hard object. For more information, call 1-800-824-BONES, or visit www.aaos.org.

American Academy of Orthopaedic Surgeons

We keep you well connected.

Visual metaphors were engaged to raise public awareness about bone health in three ads, each designed to fulfill a different objective. The ads share a layout and a quick-hitting approach to imagery. Each is a visual metaphor that combines two unrelated objects. A bone itself is the star in two of the ads: In one, a bone in an hourglass crumbles into dust to illustrate the increased risk of osteoporosis in aging bodies; in the other, it helps to form a dumbbell to promote bone health through exercise. A third ad's cast (of characters) stands in for a slide to represent playground accidents.

Crunch Gyms

Project: Posters/postcards
Agency: DiMassimo Brand Advertising
Executive Creative Director: Mark DiMassimo
Creative Director: Carol Holsinger
Art Director: Sandra Scher
Copywriter: Phil Gable
Illustrator: Sara Schwartz
Photographer: Arthur Cohen

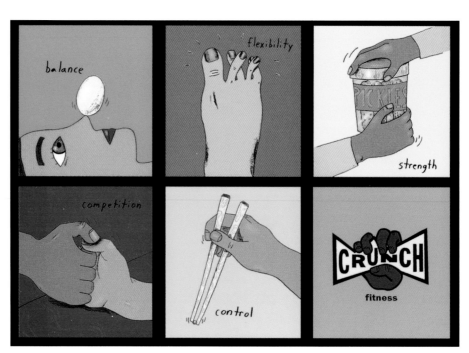

More powerful than a pickle jar's seal...able to control a wee pea with long sticks...these and other kooky members' traits are served up to illustrate the benefits of working out.

Boldly colorful, playfully weird images help to promote a chain of gyms called Crunch, and the benefits of working out. Illustration was picked over photography in this campaign because of its advantage in rendering the absurd. The style had to match the brand's image—urban, funky, fun, and unexpected—simply enough to keep from interfering with the message.

Five images, each conveying a different benefit: Crossed toes signal "flexibility"; an egg on a nose says "balance," of course; thumb wrestling demonstrates "competition"; a pea held by chopsticks shows "control"; gimme "strength" to open the pickle jar. The images also translated to T-shirts and in magazine and newspaper ads. Diversity comes across in different skin tones.

But the absurd isn't limited to illustration, as another series shows. Three photographic executions play up the chain's "No Judgments" tagline without reference to body image. Instead, visuals show members engaging in strange behavior at the gym, without self-consciousness or the reaction or even the notice of people around them. At the same time, the photos depict some of the gyms' offerings: treadmills, boxing, mini-trampolines.

Those aren't professional models...deliberately. The designers chose regular people instead of buff models to add heft to the all-inclusive theme.

"Smile when you give me the bird." The idea that everyone—no matter how bizarre—is welcome at this gym is suggested by three posters in a photography-based campaign.

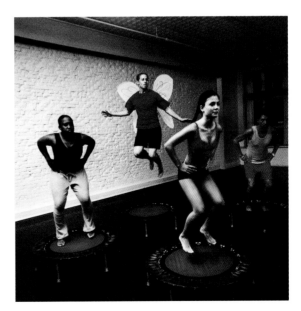

Unilever Canada

Project: Ad/poster campaign
Agency: Grey Worldwide Toronto
Creative Director: Marc Stoiber
Art Director: Shelley Weinreb
Copywriter: Shawn McClenny

Every sane man dreads the moments when his beloved asks, "Do I look fat in this dress?" And if the garment in question is a wedding dress, well, the man's only recourse is to feign laryngitis. For the same reason, campaign creators knew they had to tread lightly in promoting a weight-control product to brides-to-be.

The team wisely steered away from real body types with their potential to offend. Instead they let the plastic bride and groom that top wedding cakes—traditional wedding symbols—do the heavy lifting. Their playfully pitiful adventures let the audience have a laugh while they swallow the message (which, not coincidentally, arrives on a photo of a high-calorie cake).

In the first ad of the campaign produced to run in wedding magazines, the bride breaks through the cake, while the groom dutifully attempts to retrieve her.

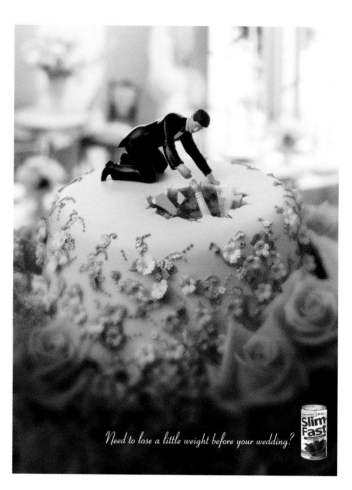

Need to lose a little weight before your wedding?

Asking brides-to-be if they need to lose weight before the wedding is a tough job but one agency had to do it...with traditional wedding symbols on a cake.

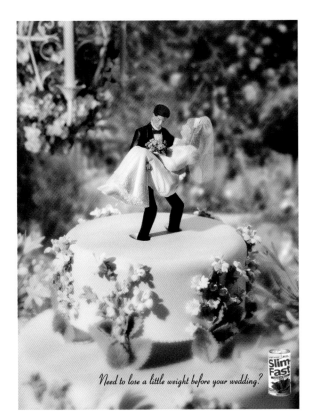

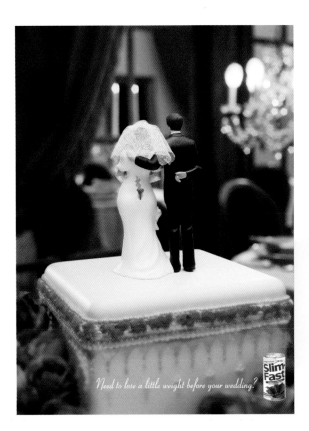

The other two ads tap into embarrassing moments that the weight-conscious might relate to. In one, the groom sinks in to his ankles as he carries the bride, likely to remind the bride of the threshold-carrying ritual she's facing after the wedding.

In the third ad, the bride's dress, too snug over wide hips, splits, revealing red panties. Why not wedding white? Red was needed to show up against the dress and call attention to the point of the ad.

Club 606

Project: Ad campaign
Agency: Grey Worldwide Toronto
Creative Director: Marc Stoiber
Art Director: Shelley Weinreb
Copywriter: Stephan Walmsley

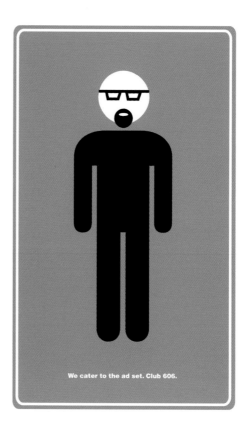

A trendy Toronto nightspot likes to play up its reputation as a magnet for models and other people in the movie and ad business. So the club asked Grey's designers to get playful in creating ads. They came up with a spoof of washroom signage, one for each of the club's three unisex washroom doors. Because the signs didn't have to do the typical job of sorting out the rooms' visitors by gender—or at least by the types of garments they wear—the graphics took a poke at other ways to stereotype the club patrons.

For example, everyone "knows" that ad guys wear black, glasses, and a goatee (and plenty tend to be bald); the model is impossibly skinny for her height; and the movie person's body totes a head so swelled it's a wonder it can be carried at all. Because they're offbeat, the ads match even the club goers who don't fit the three stereotypes.

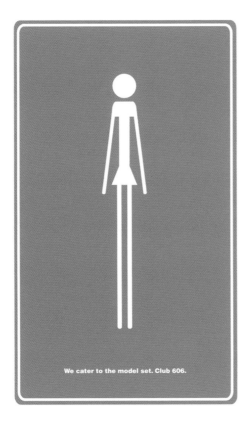

We cater to the model set. Club 606.

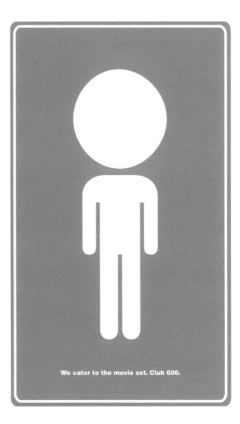

We cater to the movie set. Club 606.

The international symbol for a person changed to represent three types of hip club goers, and signs for a hot spot's unisex washroom doors.

Subsub

Project: Poster series

Art Director/Designer: Slavimir Stojanović/Futro

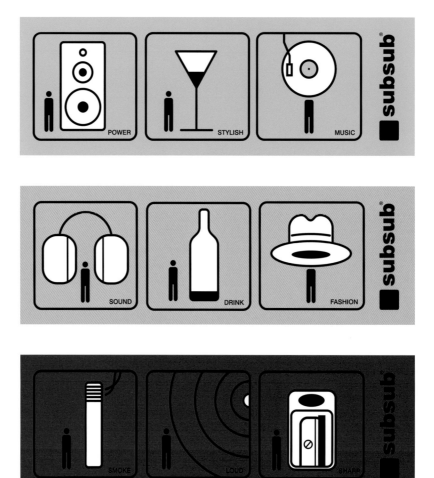

Images for a nightclub in Ljubljana. Slovenia. used playful pictograms to promote things you can do in the club. Armless. clothespinlike people icons interact with a series of props that stand for clubby ideas such as drink. smoke. fashion. and loud music. By the way. the name is short for "subculture subway" because the building resembles the metro station.

The Sports Celebrities Foundation

Project: Ad campaign
Agency: Grey Worldwide Toronto
Creative Director: Marc Stoiber
Art Director: Shelley Wienreb
Copywriter: Christina Angelopoulos

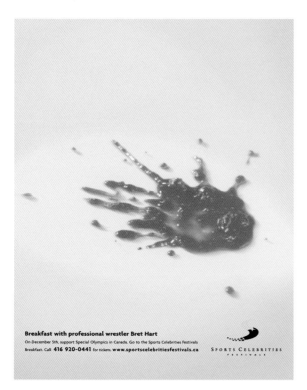

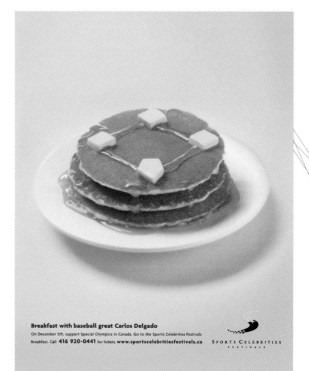

Bases are loaded onto a pancake stack. and strawberry jam looks like fake blood gone splat. The images link sports with morning munchies to promote a star-athlete-studded breakfast fund-raiser.

Procter & Gamble

Project: Ad campaign
Agency: Grey Worldwide Toronto
Creative Director/Copywriter: Marc Stoiber
Art Director: Richard Mirabelli

 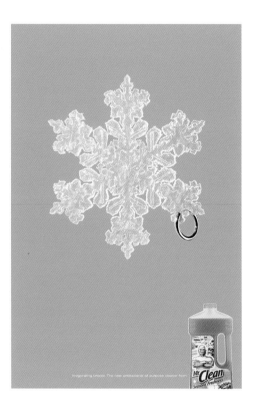

Mr. Clean, an old-standard housecleaning liquid, has a familiar
brand in the smooth-scalped bodybuilding genie in white. He
wears a small gold hoop ring in his left ear. This feature is always
in fashion for genies, but it put him way ahead of the young, hip
human males who have caught up only in the last ten years or
so. In fact, the agency considered the earring to be such a strong
component of the character's "DNA," that it helps to advertise the
product's new seasonal scents.

*Just when you thought everything
that could be pierced had been...
fruit, a flower, and a snowflake
get a left earring to strut their
collaboration with a household name.*

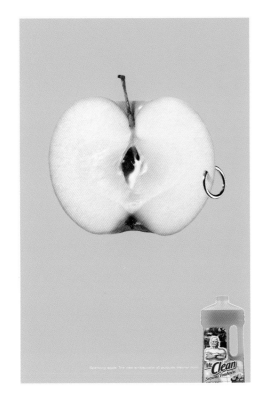

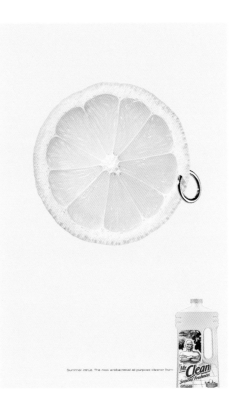

The character lent his earring to representative images of the
scents: a stargazer lily, a lemon, an apple, and a snowflake. As the
earring links the brand to its new scents and their seasons, it seems
to tap into the body-piercing trend. That, in turn, works to make the
product acceptable to a new, younger-than-traditional audience, kids
with household shopping and cleaning responsibilities. On each ad,
the same color in the product, symbol, and ad background rein-
forces their connections.

Procter & Gamble

Project: Ad
Design: LOWERCASE and Taylor Bruce Associates
Creative Directors: Marc Stoiber
Art Directors: Tim Bruce, Doug Bruce
Designers: Tim Bruce, Doug Bruce, Jared Tekiele
Copywriter: Shawn McClenny

Main Head

Project: Project name
Design Firm: Design firm name
Designer: Designer name

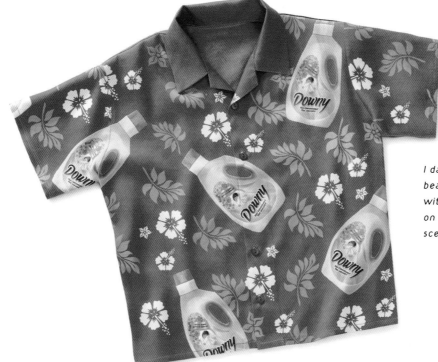

I dare you to wear this to the beach bar: brand packaging merges with the garish colors and patterns on a tropical shirt to flaunt a new scented product.

Another new scent announcement, this one is tropical. The whole container of Downy fabric softener—not just a detail of the brand— becomes part of the kitschy pattern on a Hawaiian shirt. It's a deliberate cliché to get across the message. The fact that it is a shirt also reflects the product's use, especially because this particular type of shirt is vacation or recreation wear so it's meant to be soft and comfortable, not stiff.

Boyds Coffee

Product: Ad campaign
Design Firm: Mires Brands
Creative Director: John Ball
Designer: Gretchen Leary
Photographer: Harry Chamberlain

On packaging and a pin, a smiley face drawn into the surface of the drink transfers to the product's image (in the tradition of the personified Kool-Aid pitcher).

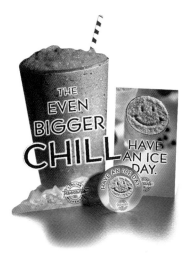

The round rims of two different-flavored cups of milkshake help to spell "cool."

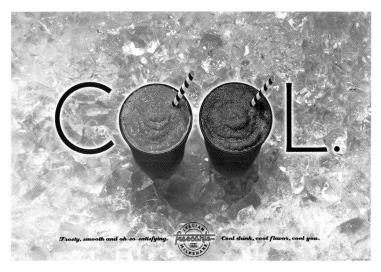

What, another frosty milkshake product? Right, so John Ball and Gretchen Leary, the creators of Frescante Ice's launch campaign, sought to set the product apart by making it look like fun. They did it by playing with an aerial view of product-filled cups. In an ad for a frozen drink, the cups fill in for the two Os in "cool" against a background of ice. In fact, the ice anchors the cups. A different color in each cup shows that the drinks come in different flavors. An icy blue unifies everything else in the campaign.

AIGA DC

Project: Breakfast meeting series invitation
Design Firm: Mek-aroonreung/Lefebure
Art Directors/Designers: Pum Mek-aroonreung, Jake Lefebure
Photographer: John Consoli
Copywriter: Cheryl Dorsett

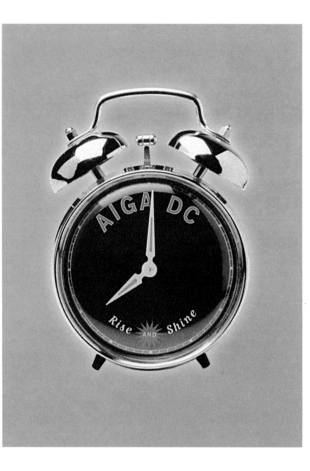

A card deck featuring photos of an alarm clock and altered packaging for breakfast products alerts designers to a series of breakfast meetings. They are meeting speakers' names and topics in place of the product's familiar brand names.

You think it's easy to get other graphic designers out of bed after a long night of Photoshop and Spraymount? What if the lure is not the opportunity to design the next Nike logo? The designers who went for that challenge created an invitation to a series of breakfast meetings with a goal of making recipients "do a double take." They used an image of a full-size alarm clock and a visual parody of breakfast-related items.

Four meetings, one speaker, and one card each were sandwiched between cover and registration cards, and held by a paper band. The designers chose visuals to match each speaker and topic. In fact, the speaker's name and topic merge with the product visual. That results in the sight of a familiar brand's familiar packaging, but with the name you know changed to that of the speaker.

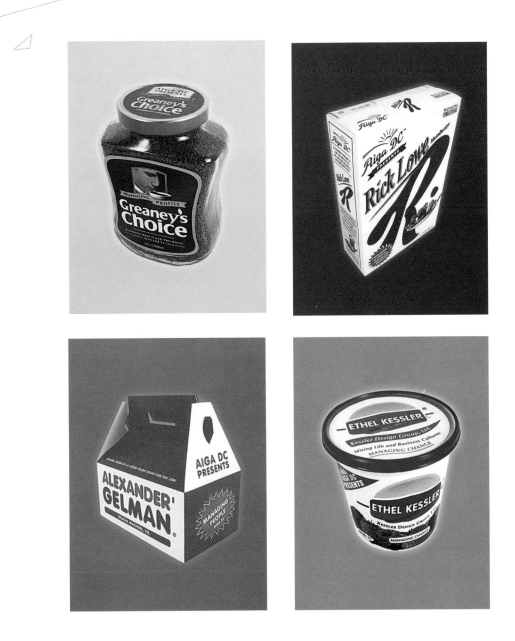

For example, talk about variety, as did the speaker whose topic was "managing people." That speaker's card is illustrated by his name on a box of donuts, implying all the varieties within. The speaker on "managing change: mixing life and business cultures" got her name on a live-cultures-yogurt container. "Managing structure" put the speaker's name on a fortified-cereal box (with the big script letter altered to his first name's initial). "Managing profits" is on a coffee jar. Those two hold less-obvious connections to the talk topics than the others, but they're no less potent morning symbols.

The design team completed the wake-up call with the use of bright, mostly warm colors, and a reminder system on the band: it contains four peel-off stickers—one with each speaker's icon, the meeting date, and the group's name—for marking the dates on a calendar.

Meat New Zealand

Project: Ad campaign
Agency: August, Lang & Husak, Inc.
Photographer: ©Pohuski Studios, Inc.

Companies that process meat into hamburgers look for raw material that is the same from patty to patty. So, for a client that sells the meat to the pattymakers, August, Lang & Husak wanted to do more than just show photos of raw cuts of meat, as the client's competitors tend to do.

The agency sought to visually convey the "consistent burger patty" benefit "with a cookie-cutter hamburger-wallpaper layout," according to the firm. Reinforcing the theme, the look of the ads in the series is also consistent, with only the headlines and text changing. "Theoretically, we could have given the patties just about any shape—squares, perfect circles, the shape of the logo," but cows reflected well on the source of the product.

A small herd of cloned cattle is cut out of beef to tell viewers that the product makes consistent burgers. The layout is the same for the series: just the text and headlines change. "Cash. Cow. Repeat." in one: in another: "So consistent, you may experience déja moo."

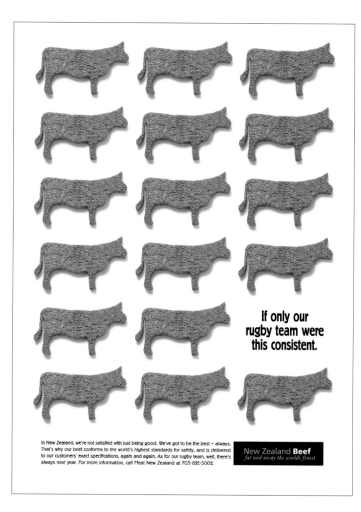

Project: Ad campaign
Agency: Grey Worldwide Toronto
Creative Director: Marc Stoiber
Art Director: Alex Beker
Copywriter: David Savoie

*The universal symbol of
people with disabilities
goes to camp. In one ad,
the symbol points a hot
dog on a stick to a campfire.
In the other, the fishing
child wears a reversed cap.*

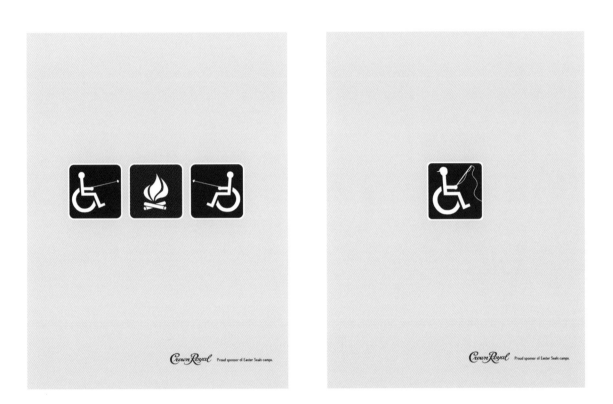

Thumbnail Creative Group

Project: Moving announcement
Creative Director: Rik Klingle
Designers: Lindsay Rankin, Valerie Turnbill
Producers: Judith Austin, Paul Townson
Illustrator: Rexford Lavado

A cockroach, a rat, and an
overflowing toilet are a few of
the icons that need no words
to explain—and announce—a
design firm's move.

Doing time in its former challenging office space obviously didn't drown Thumbnail Creative Group's sense of humor. To help its clients and suppliers keep theirs, the group drew its understandable reasons for leaving on its moving announcement. Give thanks for your unblighted studio or groan with empathy as you view iconic depictions of "adventures" encountered at the firm's old place: vermin and pestilence, plumbing and electrical disasters. The red circle and left-to-right diagonal slash over the icons send the welcome news that the firm has left those woes behind.

The piece is bright and bold, to let the amusing icons appear front and center. "Viewers are meant to discover the meaning of the piece as they view each icon," said Rik Klingle.

Two diagonal cuts in the black card held the tiny piece in place, centered in the envelope. Recipients could see the theme right away because the envelope is translucent to afford a peek at the cover girl: a realistic yet, (I'd like to think) larger-than-life, cockroach. The black-and-white, red-trimmed images stand out against a bright marigold-yellow field. To help keep the memory of the old office's challenges alive in the minds—and offices—of the firm's clients and suppliers, the icons are peel-off stickers. The 2³/₄-inch-square, glossy piece is accordion-folded into six panels.

Degenkolb

Project: Moving announcement
Design Firm: Skaggs Design
Art/Creative Directors: Jonina Skaggs, Bradley Skaggs

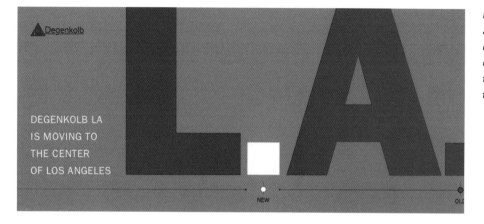

Punctuation. initials. and a bit of color are visual metaphors for an office. a city. and the office's move from the city's outskirts to its hub. respectively.

On the back. the white symbol and the vertical lines call attention to the new office.

Have you heard of the ancient *Name That Tune* game show? In it, the contestant who needed the fewest notes to recognize the song won. From a design standpoint, Skaggs Design got across the message of an engineering firm's move in one just note. Actually, it's a period, which the designers whitened to symbolize the move from outside of Los Angeles to the center of it.

The period after the *A* remains purple to stand for the old address outside of the city, while the initials' monumental size and boldness contribute to their representation of the vast physical city. The type's scale also hints at "the self-important attitude of its population," Bradley Skaggs said.

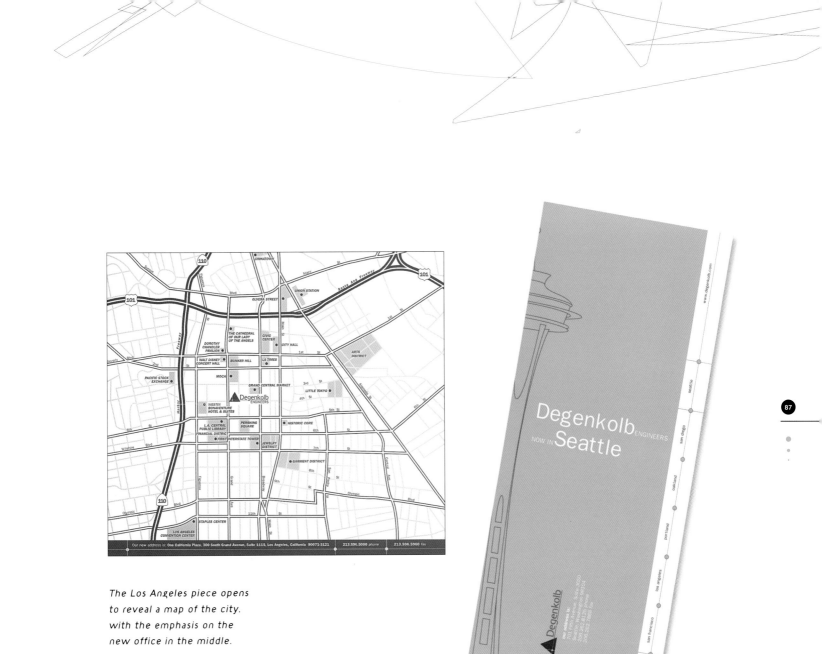

The Los Angeles piece opens to reveal a map of the city. with the emphasis on the new office in the middle.

On the other side (facing page, below), vertical lines and a whitened circle set off the new office among the firm's other locations. The others get only a circle outline. You can see the same vertical-lines system of identification on the notice of the Seattle office opening. On that card, though, the city symbol is more literal. It's a drawing of the Space Needle landmark, shown partially on the front, and wrapping the rest to the back.

The style of the pieces and the entire identity suggest something more. Because the firm specializes in structural engineering, Skaggs intended elements such as those fine lines to suggest precision, structure, and functionality.

The vertical lines do the same job on another new-office announcement.

Orrick, Herrington & Sutcliffe LLP

Project: Party invitation
Design Firm: Greenfield/Belser Ltd.
Art Director: Burkey Belser
Designer: Jill Sasser
Photographer: John Burwell
Copywriter: Lise Anne Schwartz

O-PEN HOUSE
Come celebrate the opening of our new Seattle offices. Please join us for drinks and hors d'oeuvres on Thursday, May 24, 2001, 5:30–7:30 p.m., 719 Second Avenue, Suite 900, Seattle, Washington.

RSVP to Ansley Zeitler at 206-839-4313

ORRICK, HERRINGTON & SUTCLIFFE LLP info@orrick.com WWW.ORRICK.COM ORRICK

Green-wrapped round sushi get together in a circle to mimic a law firm's logo and ad campaign, and to get clients into a party mood.

A San Francisco–based law firm wanted an invitation for its party to introduce new office space. Greenfield/Belser's creative team debated whether to follow the law firm's ad campaign that always features a single round image (to reflect its Zen *O* mark) surrounded by a lot of white space and minimal copy, said Lauren Hodges.

"The client, enamored with the ad campaign concept, pretty much made the decision for us." So the designers set about cooking up elaborate designs with multiple foldout panels, ultimately rejecting those in favor of the ad campaign's elegant simplicity...and raw food. You see the result here...a simple, flat, glossy postcard.

The designers attached a few parameters to their search for the card's ideal graphic. At the base was their typical quest for something intriguing. The image also had to imply a party, and be round, and green, the color of the firm's logo. Sounds like sushi, and the designers worked on versions that used just one big piece, wrapped in long, peeled cucumber slices for the color.

But the graphic seemed too solitary—lonely even—to represent a party, so it evolved into nine pieces arranged in a friendly circle. After the recognizable O, the grouping is the strongest nonverbal cue. It conveys "something for many," Hodges said.

Your clients will appreciate it if you take every opportunity to flog the brand. The card's other side holds a map to the new place, with the address pinpointed by, of course, a green circle outline. Here, though, it is a bit out of uniform, but for a functional cause. It's screened, not solid, to avoid hiding map details.

The logo also puts in an appearance on the map on the invitation's flip side.

Canadian Home Planning

Project: Poster series
Agency: Grey Worldwide Toronto
Creative Director: Marc Stoiber
Art Director: Raul Garcia
Copywriter: Craig Burt

Three posters to announce a launch party for a home-renovation magazine hit the nail on the head as the hammer and its comrades in arms prove to have other uses.

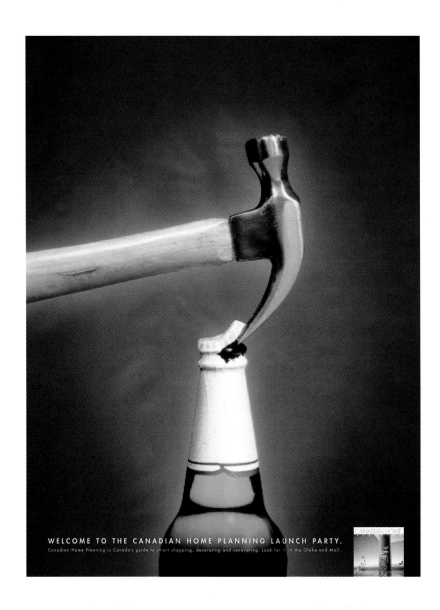

WELCOME TO THE CANADIAN HOME PLANNING LAUNCH PARTY.
Canadian Home Planning is Canada's guide to smart shopping, decorating and renovating. Look for it in the Globe and Mail.

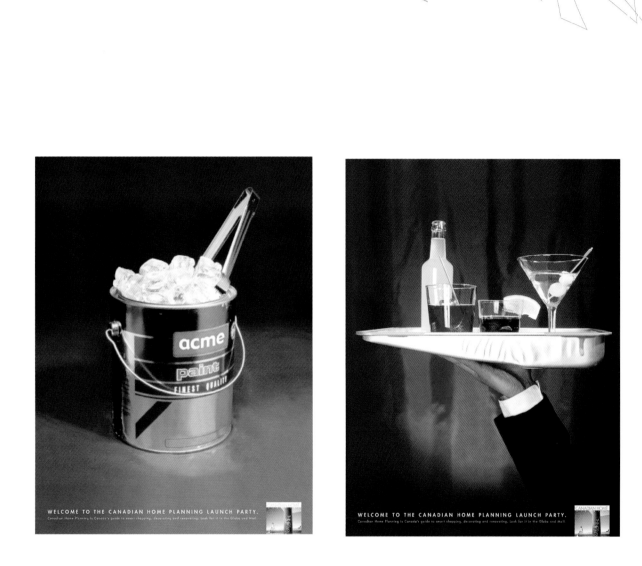

More party images...these relate not just to the name of the party host, but also to its business. *Canadian Home Planning* launched in spring 2001 as a high-end magazine of renovation ideas for homeowners. To announce the launch, Grey did a series of posters that merge icons of parties with those of home renovation: a hammer acts as a beer-bottle opener; a paint can becomes an ice bucket; and the hand of an elegantly suited waiter balances drinks on a used paint tray.

Sagmeister Inc.

Project: Commemorative pin
Concept: Stefan Sagmeister
Designers: Martin Iselt, Mathias Ernstberger
Photography: Tony Cenicola, Tom Schierlitz
Copywriter: Karen Salmansohn
Initial Modelmaker: Yuji Yoshimoto, Studio UG

Although designers often are called upon to put out fires, they're not in the same category as the real thing. So the 2001 terrorist attacks on the U.S. spurred Stefan Sagmeister to take action of a different sort. The disaster left him "just feeling really useless as a designer (versus, say, firemen or rescue workers)." He conceived of pins, each about the size of a U.S. penny, and made from a piece of the World Trade Center "that refused to be destroyed." So "A Heart Unbroken" symbolizes indomitable spirit and strength.

The heart shapes obviously and universally stand for love. Less obviously, the shape is intended to symbolize permanence— the two-lobed heart shape was in use before the last ice age, Sagmeister said. It sends a further message of religious tolerance and unity: Buddhists, Christians, Hindus, Jews, Muslims, and Celts all use the symbol. Finally, the heart is encircled to reinforce the idea of unity.

Before finalizing the heart, the designers also had considered a phoenix for its connection to rising out of the ashes. They rejected it when they found that the phoenix's story isn't universally familiar. The other problem: made from battered metal, "the phoenix wound up rather military looking (like an old eagle medal)," Sagmeister said.

For a memorial pin, scrap metal from the World Trade Center is formed into a heart because of the shape's positive symbolism to many cultures.

Here's how the designer came up with this unusual art supply: Sagmeister's research revealed sources for the scrap steel needed to make the pins. He heard estimates that the sites would ultimately produce one million tons of rubble. One month after the disaster, 250,000 tons had been taken from the site by truck and barge to a landfill in Staten Island. It takes less than two tons to make 300,000 pins.

The charitable fund-raising project continues to offer challenges beyond sourcing the steel: "For one, it's a self-generated project and as such, without a client, we have to talk many people into helping us. For me, it's a first and a difficult thing."

Polar

Project: Ad
Design Firm: Starshot GmbH & Co. KG
Art Director/Designer: Lars Harmsen

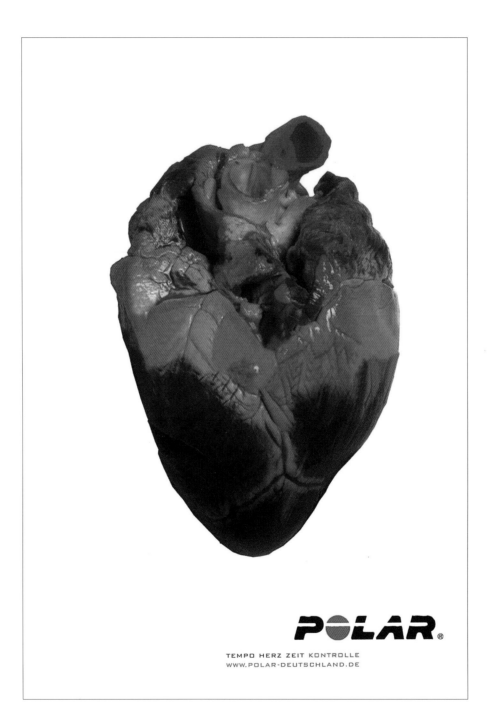

The heart takes an organic, not Valentine, shape to advertise a company that makes heart-monitoring exercise equipment and watches that measure athletic performance. Lars Harmsen, art director of *Starshot byke style* magazine and most of its ads, found this raw stock photo to be just what the doctor ordered.

The image "says everything. Its pureness says power and health," Harmsen said. The image also is provocative—even shocking—enough to draw the attention of the extreme-sports-loving readers of the magazine.

Although the story of the ad's creation had a happy ending, consider it a cautionary tale with this moral: Be careful what you wish for...your client may "get" it. Harmsen begins the design of each ad with the intention to make it look like part of the magazine. "The previous ads of Polar were really boring and didn't fit into our concept. They asked us to do a product-related ad: 'please not too stylish.'" The clients rejected the first ad he mailed them.

"I was so angry because it took me more than half a day to have it done that I said: 'You have no idea what stylish means.'" A half-hour later, he mailed the client the bloody-heart idea and his handwritten comment: "This is stylish!" "I never expected them to like it. It was more like a joke." Harmsen was already working on a more serious design when the client e-mailed him: "Go for it! We love it." So did the readers, who added clicks to the client's Web site.

Skip this one if you're squeamish.
Fortunately. the squeamish don't read
Starshot byke style *magazine. so the*
bloody heart was a natural to adver-
tise a company that makes perform-
ance- and heart-monitoring watches.
The German translates approximately
to "frequency/tension/speed control."

95

Cannondale

Product: Ad
Photo Concept and Photograph of Athlete:
Kai Stuht/Starshot
Photograph of Mountains: Cannondale
Design: Javier Alberich/Cannondale

Another ad in *Starshot byke style* magazine uses the human body as a diagram with labeled parts that relate to features of a mountain bike line. For example, the first call-out, referring to decals, corresponds to the tattoo on the model's lower back. "Single-sided design" neatly refers to the shoulder of the lone arm supporting the body. "On the fly lockout?" There's the locked elbow. And the wrist that's taking all the weight helps to illustrate number 4, the "tapered titanium axle."

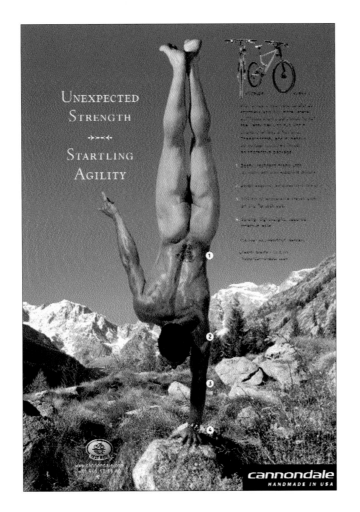

The body belongs to Cedric Gracia, a member of the company's bike-racing team. It's significant to the product's main feature that it is his left arm doing the work. On most bikes, two "arms" hold the front wheel in place. This bike uses only one, on the left side of the bike, so it's known as the "lefty fork." "Of course, it looks really strange because of its asymmetrical construction, and most people would say 'well, this couldn't work; it's not strong enough,' but it is," said Lars Harmsen, art director of the magazine. The photo parallels the strength of a powerful human body with the frame of the bike.

How do you think this image came about? Is Gracia standing on his hand in the mountains? Was he shot standing right-side-up, then flipped digitally? Any other ideas? Read on to see how it was done.

The ad is one of a campaign designed by Cannondale that features their team riders with various images. Subsequent versions have changed the color of the background and rendered it solid to make the text more readable.

Designer Javier Alberich "surgically removed" Gracia from the ropes and the white-draped studio background, then straightened the athlete's posture so he could appear to accomplish the feat alone in the mountains. (When Harmsen first related this story, I thought he was pulling *my* leg, so he proved it with the image on the right.)

How it was done: Cedric Gracia actually is holding himself up on one arm only through the ingenuity of the photographer and the Photoshop magic of the designer. "We met Cedric in southern France during a trade show, fixed his feet into a strong rope and pulled him up... horrible conditions!" Lars Harmsen said. (The obvious lesson here: Be careful whom you talk to at trade shows.)

Here's a close-up of the "lefty fork."

nonstøck

Project: Ads/catalog
Design Firm: Design Machine
Creative Director/Designer: Alexander Gelman
Design Director/Designer: David Heasty

The ad promotes the Web site with this equation: Catalog (For the catalog, you see that the white represents a side view of the pages when the book is standing open, right?) + CD = Web page.

A LOMO camera + a Rolodex card = a catalog (of LOMO photography).

Icons virtually replace words in a United Kingdom "alternative" stock photo company's catalog and ad designs. They also replace numbers in equations. "Instead of featuring images from the catalog, the campaign focuses on the catalog itself and its physical qualities as an object," wrote design director David Heasty.

For example, in two DayGlo-green ads, it's the absence of words as much as the color that draws attention.

The catalog expands on the idea.
with the rebus on the front cover
identifying the book as a collection
of business-related photos.

Inside the catalog, another in
the equation series identifies
the work as the result of the
partnership of the stock photo
firm and its German affiliate.

University of Southern California (USC)

Project: Map/poster
Design Firm: Gregory Thomas Associates (GTA)
Creative Director: Gregory Thomas
Designer: David La Cava
Illustrator: Frank Mak

Finding the way around any university campus typically challenges first-time visitors, including parents, prospective or new students, and event attendees. This map was intended as a welcome guide for those unfamiliar with the parking system or the locations of buildings such as theaters, stadiums, and dining facilities.

The designers divided these popular destinations into four categories: "Entrances and Parking," "Galleries, Lectures, and Performances," "Athletics," and "Dining." Each category got its own color so viewers could quickly connect the map to the legend. The palette, using the school's colors, was meant to look fun and welcoming.

More meaning to the color choices: "Entrances and Parking" is the first information a new visitor needs on arrival, so the category is green—the color of the "go" traffic signal and spring. "Galleries, Lectures, and Performances" is purple, which represents the arts. It's listed second, because most visitors come to the campus to attend these events. Trojan Red represents "Athletics" because it's the bolder of the school's two colors. "Dining" is colored gold, because it is USC's second color, and because yellow often symbolizes food (which is why it's often paired with red in the identities of restaurant chains).

The legend to the right of the map is colorcoded and numbered to identify the color-highlighted, numbered areas on the map. The same code is in effect with the detailed descriptions on the map's reverse side. Buildings that aren't likely stops for this target audience print in gray, with a three-letter abbreviation code. These codes are spelled out on the right, but only in gray type that is half the point size of that of the hot spots.

The three-dimensional, yet simplified, illustration is another useful feature of the map. It shows the relative size and shape of each building without extra distracting detail, making it easier for visitors to identify each building. What's more, the designers planned the map to be updateable. They have only to add a color—and take out a photo—to add a category.

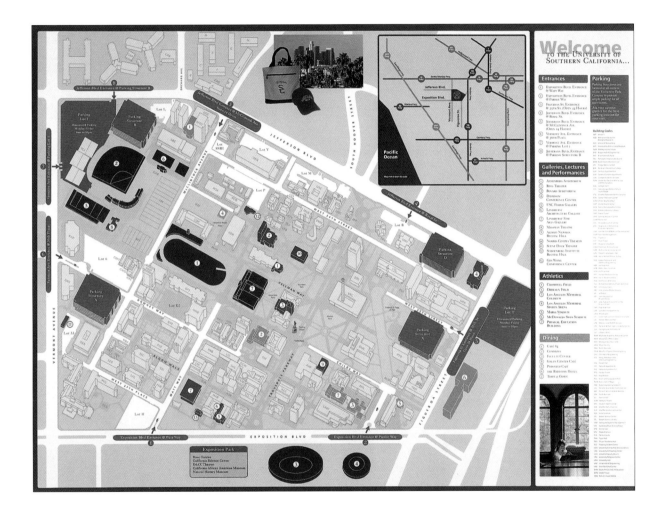

Color and numeric
codes help visitors
find their way
around campus.

And Partners

Project: Identity brochure

Creative Director/Designer: David Schimmel

A different type of visual appears on the promotion/ identity of And Partners. In fact, the grid of rectangles *represents* type—typography, to be precise. The grid and the debossed dashed ampersand on the legal-sized envelope visually cue the information graphics inside. Big words ("21 authentic And Partners ampersands") and small (a list of typographic styles) preview their meaning. That's needed because the graphics don't start really communicating until the reader gets inside.

The cover of the booklet in the envelope tells of the twenty-one Univers styles Swiss typographer Adrian Frutiger designed in 1954. Starting with Univers 55, expanded it, condensed it, and varied the stroke weights. To link Frutiger's creative exploration with that of his design firm, David Schimmel devoted each page of the booklet to an ampersand set in one of the twenty-one Univers variations. It doesn't take a Mensa member to know that the ampersand refers to the "And" in the firm's name.

The ampersand prints in dashed lines (suitable for tracing, as the envelope copy playfully suggests). And everything on the one-color piece prints in red-orange. But look to the rectangular diagram for the biggest information graphics story. Arranged in twenty-one outline rectangles toward the lower right of every "ampersanded" page, the diagram acts both as folio and style measure. With every page turned and style viewed, a solid rectangle moves from bottom to top and left to right with every page.

That rectangular, tiled diagram on the envelope of a design firm's promotion refers to the twenty-one typographic styles of ampersand inside. So does the debossed ampersand (which is so subtle on the piece, it might not be visible in the photo you are looking at).

And Partners Thin Ultra Condensed

And Partners 57 Condensed Oblique

Those tiles go to work inside the booklet.
The solid box moves sequentially from top
to bottom. left to right. The passing pages
cue readers to the order and number of
the typographic variations and the pages.
For example. the filled-in tile on the left
flags the first variation: the solid in the
third row. second from the right. counts
the eleventh variation.

Applied Materials

Project: Shopping bag
Design Firm: Gee + Chung Design
Designers: Earl Gee, Fani Chung

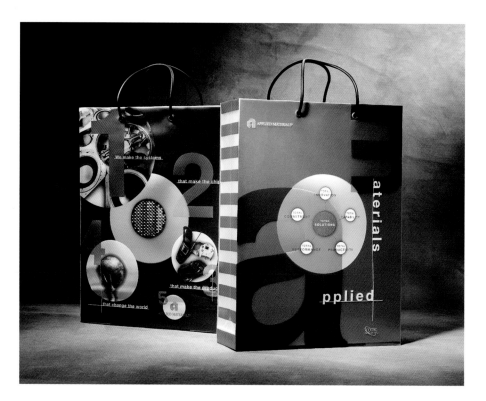

Count on graphics to get across tough concepts. Here's a pictographic description of silicon chips' role in the "big picture."

Why give out trade show bags that just carry things inside when their exteriors can also carry the message of the company? That was the thinking behind the design for Applied Materials, a supplier of semiconductor manufacturing equipment. On it, Gee + Chung Design allowed the graphics and numbers to do most of the promoting.

On one side, the designers convey the company's lofty-sounding description, "We make the systems, that make the chips, that make the products, that change the world." They used numbers "to draw viewers into the information, establish a hierarchy, and break down the statement into four manageable phrases." The company's role is number one, and bigger than the others. In fact, the numbers and the circles that enclose the images get progressively smaller as the statement proceeds.

The designers intended the numbers, as well as the big initials on the other side of the bag, to have billboardlike impact across the trade-show floor, and be interesting and informative up close. A cardboard liner is die-cut to open the center of the bag, tied to create a circular frame around the chip in the center on one side and the diagram on the other. The die-cut serves to highlight—*back*light—those sections and add a dimensional quality to the piece. The bag prints in corporate colors, blue and copper, which are used on the coatings of their silicon wafers.

Willisau Printers

Project: Poster
Design Firm: Niklaus Troxler Design
Designer/Illustrator: Nicklaus Troxler

The New Year-greeting poster for a silkscreen printer is—appropriately—full of color. It's also serves a functional purpose with a minimum of words. The poster's a calendar grid of 365 rectangles that lets the viewer see the whole year on one sheet. Twelve rectangles run across the width to represent months, with their days and weeks stacked below them.

The code continues: The designer assigned a color to each day of the week. Viewed from top to bottom: Monday's always blue (maybe a subtle reference to the designer's jazz associations), Tuesday's fuchsia, Wednesday's green, and so on. Months with thirty-one days fill their stacks with color. White fills the missing days at the bottom of shorter months, like February and April.

J. McLaughlin

Project: Press folder
Design Firm: Rhonda Weiner Graphic Design
Art Director/Designer: Rhonda Weiner
Copywriter: Laura Laterman

It wouldn't be fitting for an apparel retailer to send out printed materials that don't match the style of the clothing it sells. So when a chain that sells "preppy" clothes for men and women needed a mini press kit, Rhonda Weiner designed its folder to look like a man's shirt. Not only does the folder not use words, it didn't even use ink to reflect both the type of product and the style of the company.

No ink was harmed in the making of the folder: Weiner chose a duplex stock to provide the beige color for the shirt on one side and the light-colored ivory collar for the other. That way she didn't need to print on either side to show the contrast between them.

The company's own woven label adheres to the appropriate place on the collar, adding credence to the shirt theme, while again saving the cost of printing the folder. The printers weren't left out of the project entirely, though. The "handkerchief" slipped into the die-cut pocket of the folder is actually postcards printed with illustrations of the company's new line of handbags. To seal the shirt theme, the folder closes with a real button.

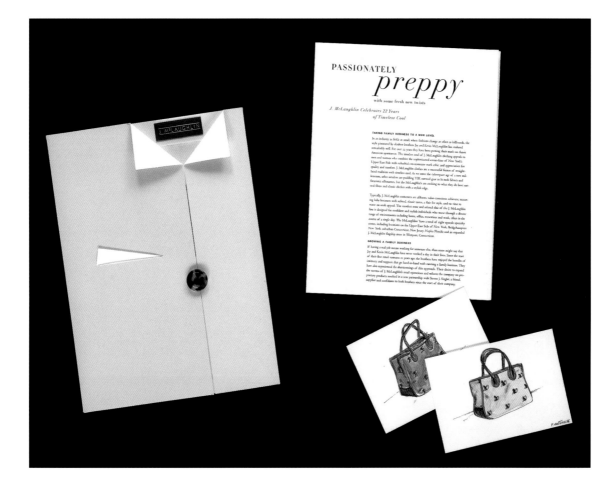

The "collar," woven label,
and the real button on a press
folder leave little question
about the products and the
style of the company.

Raise your hand if you've ever dreamed of designing the next Nike swoosh. If you didn't love a design challenge, you swashbuckling designer, you'd probably never agree to take on a logo project at all. When you think about it, the task alone sounds like the ultimate impossible dream. (Sometimes it's best just not to think about it.)

A logo has to carry the weight of the company on its tiny shoulders. It has to communicate the image, spirit, function, diverse activities, and name of a company, and to do it in a variety of media and in a range of sizes. Rare is the logo that has just one job to do. The expectations are huge.

logos and stationery

Chapter Three

And no design category has to say as much in so little space as a logo on stationery and business cards. On stationery, in particular, the logo has to communicate at least as powerfully as the letter you write on it. And yet you thrive on the limitations of that project. Sure, you may mentally roll your eyes when the client asks for the moon. But then you manage it, weighing the elements and messages, experimenting, limiting, and shaping until it all makes sense.

Of course you're not alone. This chapter holds dozens of logos and identities that rose to the minimalist challenge, despite its enormity. They represent the gamut of clients, from the mom-and-pop to the multinational.

These articulate marks scale the heights of information graphics because they capture a world of meaning in a nutshell. Some of them do so with the use of visual clichés...and that's not a bad thing because they communicate instantly and nonverbally. Some of the featured designers show you the path to the finale, designs sketched and rejected along the way, and why. The collection is here to inspire you in your current and future quests for the "impossible."

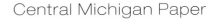

MONADNOCK AT CMP

Take a wild guess what quality this logo claims for the paper it represents. "Good" guess.

If wings alone represent one quality of an angel, a halo surely represents another. So the symbol came to mind when designer Yang Kim was asked to help a paper distributor introduce a newly represented line. In the too-simple-for-words logo, a dog-eared sheet of paper wears the burnished gold floating symbol to show that the paper is good. You expected more? That's the whole message, neatly and obviously conveyed.

On the way to this concept, Kim played with type-only solutions, rejecting them as too corporate-logolike; and various renditions of paper, but they didn't say "good." He also experimented with other "good" images but they ended up conveying happiness or serenity.

And Kim tried contemporary styles: clean and precise with rectangular, hard-edged shapes, small gray type, and nice use of white space. You know…"all the things we were taught if we went to a design school that preached the Bauhaus mantra," which he did.

But for this logo, Kim decided he preferred a rough, crayon-casual look. He avoided a sharp-looking halo or a precise-looking sheet to keep the logo from looking like an icon. He also liked the crayon's scratchy quality to help suggest the surface of good paper.

On a light green T-shirt, the paper concept stands out best. The colors are the same except for the pastel background, which calls attention to the white of the paper.

Port Authority of New York and New Jersey

Project: Logo/maps
Design Firm: Pentagram Design
Art Director: Michael Gericke
Designers: Lior Vaturi, Don Bilodeau

In a simple graphic logo, a rail meets a plane, visually describing the role of a transportation system. The plane turns red for connections to Newark Airport; blue for those to JFK Airport.

The AirTrain Regional Rail Connections map introduces the color distinction between airports. Dashed lines showing the route pick up on the look of the rail in the logo.

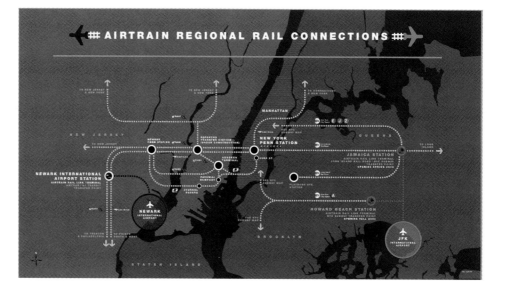

AirTrain, a new light rail system developed to link Newark and John F. Kennedy (JFK) International Airports to Manhattan needed an identity design that encompassed signage, maps, and way-finding, train graphics and interiors, even staff uniforms.

Because many of the transit system's potential users don't speak English, the maps and identity were designed to not be language dependent, said art director Michael Gericke. He and the designers developed a system that included the symbol, color coding, sans-serif typefaces, iconography, and simple representations of the airport and regional geography.

In the logo, a plane connects with a rail—a direct translation of the logo and the system's function. For every element of the identity, the design team chose bold colors against a dark background for "maximum contrast and visibility for rear illumination," as well as to mask dirt and dust in exterior environments.

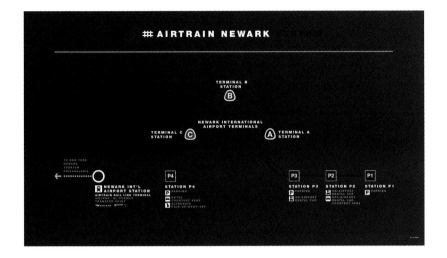

The color code expands to
the routes, not just the logos,
on the other maps. Newark's
in red. JFK's in blue.

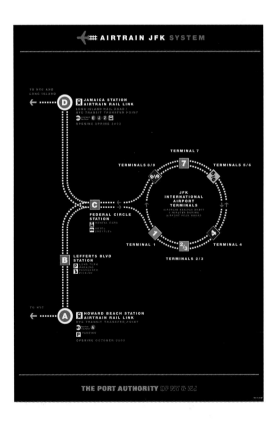

Uniform-weight sans serif type was the right choice because it tends to be most effective in reversing out of any color. It also has a no-nonsense, clear, slightly high-tech transportation look. Icons point out rental cars (a graphic of a car with a key over it), courtesy vans, and trains. "A key component to guiding and informing passengers along their route are maps that describe the AirTrain system and its connections to other regional transportation networks." The Regional Rail Connections map introduces color codes for each airport on dual, opposite-facing logos at the top—red for Newark, blue for JFK. Those signature colors follow through on individual maps for each airport.

Shapes of icons also add meaning: On the JFK map squares designate terminals; circles signify major stations, gateways from other transit systems to the airport. The colors help to distinguish terminals from each other, and to follow the color system used on airport roadway signage for cars, buses, and taxis. On the Newark map, terminals are pear-shaped to match the symbols used on roadway and way-finding signage used elsewhere in the airport.

The dashed route lines pick up on the look of the logo by mimicking the weight of the "rails." On every map, the yellow icons portray connections to transit systems beyond the airports.

Zurich Capital Markets

Project: Business cards
Design Firm: Pentagram
Designer: Michael Gericke

Zurich Capital Markets, a global financial consulting company headquartered in Switzerland, wanted not just business cards, but identity cards—cards that would reflect the flexibility of their solutions, the originality of their approach, and the individuality of their employees and clientele.

Within the minute real estate of a typical, two-sided business card, designer Michael Gericke was able to include much more than the usual name and contact information. With a series of icons, arranged in a two-by-four grid on the back of the card, Gericke allows each employee to specify traits and preferences such as the mode of communication she prefers, whether she is right- or left-handed, her personal interests. Even esoteric information like an employee's personal icon (earth, wind, fire, or water) appears.

In addition, employees are able to identify common traits or interests by matching up their personal barcodes located at the bottom of each card. Gericke extended his visual allusions through his choice of colors (predominantly red and white—the colors of the Swiss flag), and the use of a grid (an homage to the International Typographic style that emerged in Switzerland during the 1950s). Not only are the cards economic and playful, but they can be understood universally—a good thing for a global company.

			1	2	3	4
			5	6	7	8
			9	10	11	12

Xe [54]

131.30

Page Starr

Zurich Capital Markets

The Zurich Building
90 Fenchurch St.

London EC3M 4XS

W. Z. Elkins

Project: Promotional cards
Design Firm: Aue Design Studio
Designer: Jennifer Aue

"Obviously a no-budget project," noted the firm approached by a furniture and cabinet maker whose studio is in a mechanic's garage. Elkins wanted to get his name out with a piece he could hand out during gallery openings, art investors' cocktail parties, even door-to-door in upscale neighborhoods. He wanted it to appeal to contemporary and open-minded art lovers, the types of people he likes to work with (who doesn't!). At the same time, the piece needed to represent the furniture maker's Spartan surroundings and his "starving artist by choice" persona.

A gestural figure drawing communicated the end use of the company's work. In this case, the figure demonstrates the product by sitting in one of the chairs. In keeping with the artist's impoverished overhead and image, Aue used a Polaroid to shoot the products in the client's garage, then played up the raw, hip feeling by printing them as monotones.

Other cost-saving measures served to bolster the image: the job ran in two colors on low-cost paper at a low-budget local printer.

Because the name of the company gives no clue to its products, the visuals had to do it. Jennifer Aue drew the image in the furniture maker's head of how the piece would look and be used. "We chose the simple line drawings to convey the idea of the imagination, of the process of visualizing the purpose of an object."

Aue created four different cards, giving the client the option of choosing the best design for each prospect. He also uses them in place of business cards "even though they won't fit in anyone's wallet."

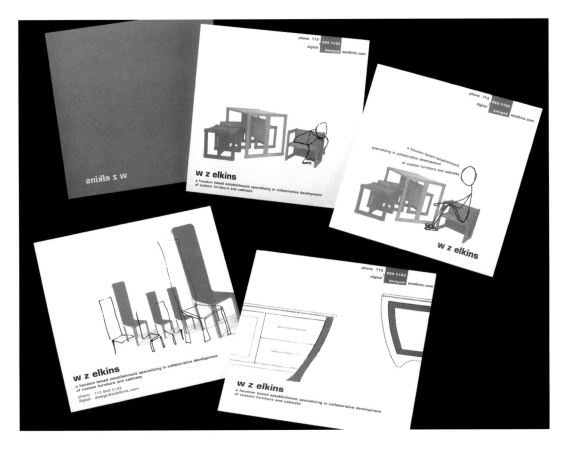

*A gestural drawing of a
human demonstrates the use
of a furniture-maker's wares.*

The Nature Conservancy/Fortaleza

Project: Logo
Design Firm: Kabenge Design
Designer: Julian B. Kabenge
Credit: Kabenge Design, ©The Nature Conservancy

The evolution of a logo: Fortaleza, meaning "strength" in Spanish, is a Web collaboration of The Nature Conservancy and four other groups. The site's an information source for organizations that work on sustainable development in Latin America and the Caribbean. It provides three main categories of supplies: human and financial resources, and management tools.

Initially, the client wanted the three categories in the logo, along with the idea of conservation of natural resources. But as Julian Kabenge began the design process, he realized that no matter how simplified, the three-category idea was too complicated for a logo, especially one meant for a multicultural audience.

So Kabenge decided to focus next on the conservation aspect with abstract leaves, three of them to symbolize the number of resource categories. In this iteration, he also emphasized the *Fort* part of the word, because it carries the meaning.

At this point in the process, the client asked for emphasis on the project's global aspect, so the globe appeared. And the conservation theme superceded the idea of the three resources, allowing for further simplification. The only nod to technology was the high-tech-looking typeface, Eurostile.

Then, the group decided that other organizations, not just conservation ones, would use the Web site. So it was time to play down the conservation aspects and play up the global and technological ones. Thus, the segmentation of the globe symbolizes the different resources on the Web site, and the diversity of the users. It also represents a computer chip. The grand finale: the leaf turns into a leaflike computer mouse attached by its cord to the revolving earth.

Sometimes a logo tries to do too much. Asked to make a mark that embodied care for environment, globalization, multiculturalism, and three categories of services on the Web site (human and financial resources, and management tools), the designer gave it a shot, and didn't like it.

The next four generations simplified the approach. keeping the idea of three. losing the clutter. The negative/positive effect on the word and the typeface on the first two survive the creative process.

The leaf image remains. this time with the addition of a globe whose curved lines suggest rotation.

The globe shrinks a bit to make the name more prominent in relation to it. The designer experiments with various leaf shapes.

Segmentation in the globe suggests the various compartments of resources on the Web site.

The work is finished: The leaf morphed into a symbol of technology: a computer mouse in the shape of a leaf. connected to the Earth by its cord.

Big Daddy Photography

Project: Corporate identity
Design Firm: Sayles Graphic Design
Designer/Illustrator: John Sayles

Avant-garde photographer Roger Kennedy asked John Sayles to develop a new visual identity for his studio "to portray how fun he is." The name Big Daddy Photography reminded Sayles of the 1950s, an era that also appeals to the photographer. That was evident in Kennedy's office furniture and the old car that totes him and his photo equipment. Then the creative process really took off: "When you think of the fifties, you think of a heavier-set person who smokes a pipe—everyone smoked then," Sayles said. With the intention of a design that was "retro, yet with a flair of newness," the designer dreamed up a fifties-style, bow-tied, pipe-smoking Daddy character.

The designer was further inspired by childhood flashbacks. The project brought up memories of his dad taking indoor photos with explosive flashes, the kind that make you see spots for ten minutes. The flashes are visually recalled on the front and back of the letterhead as the gold-and-gray bursts near the word "click."

The fun image is reinforced by the cartoonish nature of the graphics. The designer used two colors and their tints for graphic reasons, not just budgetary: the color scheme includes black for film and gold/orange for the flash. Big Daddy's image repeats on filmstrip on the front of the letterhead. Even the smoke has a job to do: it rises to form a bubble to contain the word "Big."

The tab shape on every piece suggests the top of an old-fashioned camera; on the business card, it is more obvious because it's die-cut in the shape of the camera. The same shape turns up as a printed image on the back of the letterhead.

You won't find the typeface in any font catalog. It's custom-designed and hand-drawn, as is typical for a Sayles logo. He likes to design the type, "so the type gives it personality. I see a lot of logos where the type looks like an afterthought."

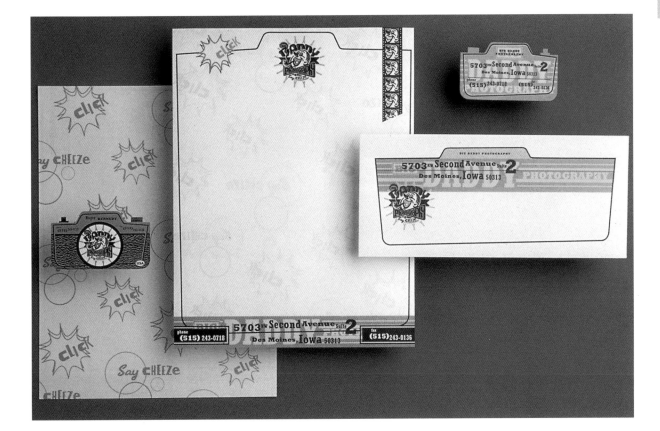

*A made-up character and typeface
and plenty of retro-camera images
form a likable identity for an
established photographer.*

Washington National Cathedral's Greenhouse

Project: Logo/identity
Design Firm: OmniStudio Inc.
Designer/Illustrator: Ginny McDonagh

The Washington National Cathedral takes pride in being one of the last cathedrals built in the Gothic style. That's an important part of its image, so it drove the design of a logo for The Greenhouse, one of its enterprises. The client provided a rough sketch with lavender forming a Gothic arched shape. The designer saw the image as a comfortable marriage of the architectural tradition of the cathedral and the horticultural elements of its plant store. As its specialty plant, lavender was the obvious choice for the organic motif.

The original, outdated logo consisted of a calligraphic treatment of the name, with small lavender stems and flowers clustered around it. The redesigned logo was destined for more than just stationery: it had to be debossed on clay pots, perhaps even welded into wrought-iron trellises. The three-dimensional uses in particular, along with dependence on in-house and quick printers, dictated a simple, one-color design.

Spending an afternoon at the cathedral, the designer drew from a wealth of visual information, both inside and out. She came away with pencil sketches of wrought-iron designs, architectural details, and window tracery. After more thinking about the cathedral (and less about The Greenhouse), she developed more pencil-and-marker sketches showing the lavender formed into:

- a gothic window tracery shape

- a design based on a wrought-iron panel of a lamp shade, with a subtle cruciform shape at its center

- a quatrefoil with lavender arranged in each lobe

The designer worked on variations of these three ideas. Because the quatrefoil design was earthier and friendlier than the two other, more precise ideas, it seemed most appropriate for the small, intimate location.

The green (PMS 555) is darker than what you'll tend to find on real lavender plants, so it provides greater contrast against white for signage. It also seems to represent all the "greenness" available at the store.

THE GREENHOUSE

Much of the challenge of the design was having enough detail, but not so much that it would look cluttered. Many stages of simplification took place. Starting with a handdrawing for an organic feel, the designer/illustrator scanned it, then cleaned up the shapes and adjusted values in Illustrator. McDonagh wanted a sculpted or carved look that drew upon the ironwork in the cathedral. She also wanted the logo to have dimension, something you'd want to run your finger across if you could.

The rounded and slightly flared serifs of the Architect Roman typeface echo the flowing formation of the plant. Because the logo is more symmetrical than not, the typeface introduces a slightly less precise tone. The Oldstyle caps reflect tradition, while appearing more inviting than a chiseled serif style. All caps give the name more prominence, support the logo's symmetry and mirror the cathedral's logo.

Earlier in the process, the designer had considered a handwritten, calligraphic typeface. She also experimented with Cezanne, Ovidius Bold (used with the quatrefoil, more informal logo. She rejected it because the typeface was more prominent than the image), and Mason, a distinctive typeface that looks "far from the Earth." She decided it was a bit too strong for the client.

Grasp Creative, Inc.

Project: Corporate identity
Designer: Grasp Creative

When Fuller Designs changed its name to Grasp Creative, a new design identity was in order. The designers tried and discarded a number of concepts. "We were probably our worst client," Doug Fuller said. Of course that's because for a designer, self-promotional items are all-important. They have to *demonstrate* the creator's skills, not just talk about them. The designers honed in on a bold, stylized *G* with curved notches cut out of its sides, as if in the process of being grasped. Although the concept was simple, it was deemed memorable, and something that could be built upon.

The concept was built upon by "hand." The designers played upon the logo's curved shape and company name with implements that grasp (chopsticks, a magnet, clothespins, a wrench, and of course, hands, an essential element of the identity). They also used implements that *can be* grasped (a magnifying glass, an arrow, a hammer, a ketchup container, the neck of a rubber chicken).

On the front of a series of business cards, a photographic hand grasps an implement that in turn grasps the words "Understanding Identity." The series includes at least six different graspers, including a hand clad in a rubber glove. The die-cut cards reinforce the logo's shape. High-energy orange is the prominent color of the identity. With the black-and-white photography and white type dropped out of the orange, the combination is a visual surprise and a fresh look.

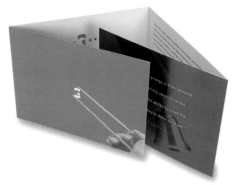

On each piece of the stationery package, another information-graphic system is at work: An orange table grid encloses the telecom contact info, with *T, F,* and *E* in a stack as labels to the left of the stacked telephone, fax numbers, and e-mail addresses. Although the initials aren't a new idea, the grid is especially effective at organizing the information.

The ever-present grasping-hand concept extends to the letterhead's back and to the envelope's flap. On the more subtle invoice, a field of orange might be considered frivolous, so it is wisely omitted. Only the logo and a small hand grasping the word "total" reinforce the identity.

Hands and a photo series of other things that grasp or can be grasped play over the memorable identity of Grasp Creative.

You haven't seen the last of the signature curves on the logo yet: They even turn up in curvy cardboard corrugations on an orange-banded package that carries the stationery package. You want still more adherence to the theme? You've got it...the package held an orange, logoed flashlight/key ring that you have to grasp (well, *squeeze*) to light.

Hardware.com

Project: Logo/stationery

Design Firm: Hornall Anderson Design Works, Inc.

There's no question that this optical puzzle clearly says hardware. And it does so with just a simple, but meaningful, variation on the bold *H*. This is similar to the visual perception test that looks like silhouetted facial profiles from one perspective, and a vase from the other. When you focus on the orange part, you see the whole screw, yet in this case, you get the hardware idea even by focusing on the white *H*. The letterform itself is built in a circle, to suggest a screw from a different angle—head-on.

The brick-orange color reinforces the theme, as does the neutral-colored grid on the stationery pieces, reminiscent of shelves in a hardware store.

The designers created the logo as part of a stationery program for this online supplier of home-remodeling and construction goods and services. The program needed to be appropriate for three diverse audiences: investors, consumers, and businesses.

The logo for a home-remodeling firm visually translates the name and describes the mission: to buy and revitalize old homes while preserving any elm trees on the property. The company operates in one of the few communities in which disease hasn't killed the elms.

Forest Technology Group (FTG)

Project: Logo
Design Firm: Group Baronet
Creative director: Meta Newhouse
Designer/Illustrator: Gus Granger

The "forest" and "technology" in the company name suggests a contrast. Indeed, FTG is an online forest-information service. That contrast comes across instantly in the logo. An image of a natural tree fills half of the rectangle and a circuit-board "tree" fills the other. In doing so, the logo straddles the organic and technological worlds, just as the company does. In the graphic, both images are needed to form the trunk. It's fitting that the natural tree is dark on a light background, suggesting daylight behind the branches, and that the techno-tree seems to be made of light—or maybe wire—against darkness.

The logo is printed in ultramarine and lime, with the circuit board part of the tree dropping out to paper white. On each piece of stationery, the logo is also embossed, as is a wide horizontal line with a small vertical representing circuits across the piece. The vertical also helps to frame and group information.

AIDS Arms LifeWalk

Project: Logo
Design Firm: Group Baronet
Creative Director: Meta Newhouse
Designer/Illustrator: Bronson Ma

127

LifeWalk is a five-kilometer fund-raising walking event for AIDS Arms, an organization that provides counseling and medical attention for those living with HIV/AIDS. This logo combines two recognizable visuals, the AIDS-awareness ribbon and a tennis shoe, with the ribbon arranged on the simple shoe graphics as a shoelace.

Seattle Convention and Visitors Bureau

Project: Logo/stationery
Design Firm: Hornall Anderson Design Works, Inc.

The Seattle Convention and Visitors Bureau needed rebranding. Seattle had been called The Emerald City since the 1970s; the identity had become outdated. The intention for the new design was to set the Seattle Convention and Visitors Bureau apart from its competitors with a unique logo that could communicate the spirit of the city.

The logo had to be compelling, unexpected, yet relevant to Seattle. It had to appeal to a diverse audience (what doesn't, anymore?) including visitors, travel and meeting planners, and the entire Seattle community. And, like many identities, it had to adapt to a broad range of applications, including stationery, brochures and other promotional materials, trade show exhibits, ads, and a Web site.

The designers solved the problem with a design that incorporates a playful, clever theme. The new identity is based on a rebus—symbols that when spoken create a word, in this case, "See-at-L." The concept doesn't stop there: not only do these symbols sound out the word's syllables, they refer to attributes the city wants to promote.

The eye (see) is meant to refer to the beautiful views surrounding the city and the richness of experiences available within it. It is also reflected in the Web address: seeseattle.org. The "@" (pronounced "at," of course) refers to its progressive technology and business. The final *L* is less meaningful, more of a stretch: The designers describe it as "the unique convergence that brings the first two elements together." What really brings it together, while reinforcing the playful nature of the logo, is the tagline, "Seattle: soak it up!" That's a reference to all there is to absorb and experience in the city, including its frequent rain.

Gentle green makes sense for the second color (with black) of an environmentally conscious city's identity, and as a second visual reference to the natural beauty of the area.

<(@L

Sound out the rebus
and get the name of
the city, along with
references to its scenic
and technological
perspectives.

Two Birds Film Company

Project: Logo
Design Firm: Group Baronet
Creative Director: Meta Newhouse
Designer/Illustrator: Bronson Ma

This independent film company wanted a logo to reflect its independence and its socially conscious subject matter. It couldn't look corporate and it had to graphically represent the film industry *and* the company's name and two partners. Showing two hands making a bird silhouette solved the puzzle simply and boldly. The circular shape suggests the beam of light needed to cast the shapely shadows. The image is also appealing, drawing on childhood memories of making animals in front of slide projectors.

Ljubljanski Kinematografi

Project: Logo
Art Director/Designer: Slavimir Stojanović/Futro

The first multiplex cinema in Slovenia is called "Colosseum." Its logo
builds a simplified image of the ancient Roman Colosseum from a film
roll, with its sprockets representing the windows.

Idol Ideas

Project: Identity system
Design Firm: Visual Dialogue

Here's an identity for a marketing consultant who specializes in creative clients. The idea bubble represents the consultant's request for something creative and memorable to distinguish her from the typical conservative, buttoned-up kind of marketing firm, said Fritz Klartke of Visual Dialogue, the identity system's designer.

The project reflects the firm's design philosophy to let the key messages determine the appropriate visual solution. In this case, it is easy to see the evolution from the concept of idea generation and brainstorming to the creation of the thought-bubble-cloud and blue-sky imagery.

Some clouds appear photographic; on the business card, they look illustrated. "All of the pieces were letterpress-printed to give a tactile dimension to the identity and give a sense of the 'handmade' to the production process." To expand on the theme, the designer die-cut the business card and promotional postcard into the thought-bubble/cloud shape, a welcome variation on the round-cornered-card trend.

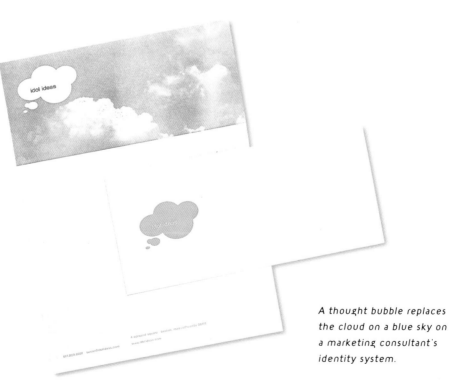

A thought bubble replaces the cloud on a blue sky on a marketing consultant's identity system.

Here's an identity for a marketing consultant who specializes in creative clients. The sky turns gray on one side of the postcard to help send the message: "Would the right marketing idea turn your gray skies to blue?" (All it really takes to turn the card's skies to blue is to turn over the card.) The theme continues on the Web site.

www.idolideas.com

would the right
marketing idea
turn your gray skies to
blue?

The die-cut postcard and business card pick up the theme and carry it further.

here's an idea...

idol ideas

new business development &
qualitative research

www.idolideas.com

José Eber Salon

Project: Logo, media kit, identity
Design Firm: 88 Phases (formerly 44 Phases)
Creative Director/Designer: Daniel H. Tsai
Designers: Luis Jaime, Prances Torres, Marco Pinsker, Julio Ferrario, Chalalai Haema

When the José Eber Hair Salon asked 88 Phases to revamp their logo and image, the designers looked for subtle references to the work of the salon. The dissected characters of the resulting logo have a fluidity that leads the eye through the words. What's more, the logo represents the way hair looks and forms. Those curves suggest curls, snipped here and there for style.

At first glance at the media kit and the identity, the colors do most of the nonverbal whispering. The scheme comes from the seasons and fashion trends in vogue when the kit mails. The intention is for the colors to be reprinted to change with the seasons and trends. What really says "hair salon" on the kit is the numbered graphic extending across each element in the kit. They derive from the color chart used in hair salons to match a customer's hair color to skin tone.

The logo and materials of a hair salon communicate beyond words with seasonal. trendy color schemes and a takeoff on the color charts used by hair colorists.

The Home Connection

Project: Logo/stationery
Design Firm: Sayles Graphic Design
Art Director: John Sayles
Designer/Illustrator: John Sayles, Som Inthalangsy

The Home Connection provides housing for previously homeless people. Sayles Graphic Design provided it with a logo and stationery package that graphically reflects its name. First, the designers built the *h* and *m* in the hand-drawn "Home" out of houses. The edificial letterforms overlap—*connect*—with their neighbors.

The logo rests on a background of connecting outlines of houses, apartment buildings, and a shining sun for good measure. The images were drawn in pencil, then blown up to achieve a happy, free-form effect. On the back of the postcard, outlines of happy-looking faces, some with halos floating above them, share space with the house graphics.

The pattern fills the flip side of the letterhead, where it reverses out of olive, into the second color, violet. The stock is cream, for a warmer feel than white. You also saw the printed-back-of-sheet treatment on Sayles' Big Daddy letterhead as well. The effect celebrates a sheet's show-through quality, which is usually considered a flaw. When viewed from the front, patterns that are printed solid on the back show through like a screen or a color watermark. And you see the pattern as soon as you take the folded sheet out of the envelope.

Although Sayles hesitates to claim credit for the technique, he doesn't recall having seen it anywhere before he came up with it. I saw the effect first on one of Sayles' designs, about fifteen years ago. Now of course, it's as ubiquitous as side-loading envelopes and rounded corners on business cards. "I wondered how it would look, if it would print. Normally people would just screen it back on the front" to get the same effect," Sayles said. The pattern also prints on the back of the business card.

A designer built houses out of letterforms, then overlapped them into a community to link to a nonprofit housing provider.

Decidir.com

Project: Logo
Design Firm: Interbrand Avalos & Bourse
Design Director/Designer: Facundo Bertranou
Designers: Carolina Lavista Llanos, Matías Magri
Digital Artist: Sergio Galeano

Radar represents the evaluation and detection work of a financial services company with offices in Argentina, Brazil. and Mexico. The logo conveys two areas on which the company focuses its financial-detection services: economic risks (conveyed by a red dot on the radar screen), and business opportunities (white dots).

*An extra slanted tine turns
two forks into a nonverbal,
nonnumeric way of saying "nine."*

A number formed by a circle and a slanted line make up
the logo for a Chicago restaurant. After creating the identity,
the designers "began to look at ways in which the restaurant
could apply the concept without simply slapping a logo
on everything."

That quest resulted in a way to say both "nine" and "restaurant,"
two four-tined eating utensils, with a slant. The first fork has a
spare that crosses over the rest to represent the hatch marks
method of counting on paper. The idea translated to match-
books, where the number prints in matchsticks arranged the
same way.

Public School 321

Project: T-shirt logo
Design Firm: Arnagraphics
Designer: Lisa di Liberto

The "One Family T-shirt" was a response, not to the September 11 terrorist attacks, but to an unfair reaction to them. On the day of the attacks, parents showed up at Public School 321 in Brooklyn, New York, to pick up their kids. On one mother's way to the school, racial slurs greeted the Muslim Arab-American. As a show of support to the woman, the school, and the community, parents of other students created a banner to hang at the entrance of the school. It read "one family" in English, Spanish, and Arabic.

The project expanded into a one-color T-shirt, planned as a PTA fund-raiser. The only requirements were to include the school's abbreviation and the theme. Designer di Liberto added her own parameters—symbols of unity, children, and peace. She began with the circle for unity, sketching varying globes and spheres, then introduced text around them.

"The idea still wasn't strong enough," said di Liberto, who looked for a simple image to represent children. "Going through some artwork, I found handprints that my daughter had made." She scanned three of them, converted them into a solid image of the prints, and formed the hands into an approximate peace sign.

Then, di Liberto turned to type, planning different treatments for each language to represent individualism as part of the larger community. One of the parents lettered the Arabic calligraphy, which the designer scanned and curved. She tried Dolores Bold for the Spanish version, but ultimately found it too playful for the image and changed it to Post Antiqua Bold. The school name and the English version set in Arial Black, with "P.S. 321" horizontally scaled to 130 percent to balance with "One Family" beneath it.

The artist finished by arranging the type in a circle around the hands. At least she thought she was finished. Some members of the PTA and school staff described the handprints as "skeletal," "ashen," and "deathlike." (Talk about design by committee!) So she offered to modify them to solid silhouettes, this time screening two of the hands to further represent the school's diversity. Those changes pleased everyone, as did the color choice: PMS 300 (blue), nearest to the banner color, for the kids' shirts; black for the adults' shirts.

The first draft: Some approval members rejected the handprints as "deathlike." The designer rejected her first typeface for the Spanish version because of its playfulness.

The final draft: A peace sign is formed by hands encircled by the slogan. The symbol says peace and children. while it turns three languages into one that's universal.

Zona Art Gallery

Project: Logo/stationery
Design Firm: Cavarpayer
Art Directors/Designers: Lana Cavar, Ira Payer
Designer/Illustrator: Narcisa Vukojević

Zona, the name of an art gallery, is written out in its logo, a symbol you can read, but there is more to it. The crossed square also describes the word's meaning, *zone,* close to its English counterpart, while it reveals its designers' architectural background. The design runs in solid as a symbol and in outline form.

On the stationery, a window envelope is a different form of the genre, and still another reflection of the gallery. Instead of the window revealing the recipient's address, as is its custom, Zona's envelope window exhibits the two forms of the logos, a two-dimensional reminder of the gallery's picture window.

The four letters of Zona make up the crossed square that is a Croatian art gallery's logo. Can't find the *A*? It's the first two strokes of the *N* plus the bottom half of the other diagonal. The window on the envelope covers the logos instead of an address to suggest the picture window of the gallery. (Still can't find it? See the upper right.)

A concept for the logo.

A proposal for the floor design.

ConAgra Signature Meats Group

Project: Logo
Design Firm: The Marlin Company
Designer: Dan Stewart
Illustrator: Kelly Hume
Copywriter: J.R. Richardson

File this logo under "no-brainer." It instantly communicates the product—a line of precooked burgers billed as tasting like the backyard grill variety.

Gourmet's Choice Roasterie

Project: Logo
Design Firm: LPG Design
Art Director: Chris West
Designer: Lorna West

Colors, a character, beans, and steam styled as a hairdo do their level best to distinguish one coffee brand from the multitudes.

It's tough to distinguish one coffee bean from another, especially on retail aisles that are almost as packed with competitors as cereal aisles are. The challenge is to create graphics that speak coffee more appealingly than the neighboring packages.

LPG Design created a character to do the job. Reminiscent of Carmen Miranda, the Caribbean-style female sports exaggerated features, and a hairdo made from a coffee bean and the steam from a piping cup. The steam also forms the barest of patterns on the background.

The designers didn't take unnecessary risks with color. The scheme is what you and the consumer would expect for the product: roasty reds and browns with gold and green. The typeface choice and the stacked type with each word condensed or expanded to the same width were inspired by two sources: travel posters from the midtwentieth century, and the burlap bags that hold the raw beans.

Association of Women's Health Obstetric and Neonatal Nurses (AWHONN)

Project: Logo
Design Firm: JDG Communications, Inc.
Designer: Sung Hee Kim

A smiling woman's image in a heart is an apt logo to convey women's cardiac health.

A nonprofit needed a logo to identify its latest program, which promotes awareness of women's cardiovascular health. So the logo had to say women, heart, and good health. The tone was important. (I can attest that women can take only so many pink frillies from health care organizations, and many, including me, won't take them at all!)

In designing the mark, Sung Hee Kim took the tone from these keywords: elegant, diverse, caring, compassionate, intelligent, simple, instantly recognizable, and of course, health care-related. That's a tall order, made even more complicated by the number and length of words in the name needed in the logo.

The familiar shape that conveys both heart and caring was a given. Kim drew it abstractly, placing a women's profile at *its* heart so they become one. The right side of the heart shape is her hair...and maybe also the left if it's *big* hair. The heartened woman smiles to show her good health. Kim chose the colors, plum and gray, to convey good health and femininity.

Project: Logo
Design Firm: Neo Design
Art Director: Louisa Caragan, Pu-mei Leng

A theater company's logo visually describes the group's signatures: fluid body movement and sets built from loosely hanging fabric.

Synenic Studio Theater is a performing company that spun off from Stanislavsky Studio Theater because the two artistic directors didn't agree on their approach, said Pu-mei Leng. Originally the logo was designed for the Stanislavsky director who later founded Synenic. In choosing the new name, he was careful to keep the old initials so he could also keep the logo.

The company synthesizes the arts of literature, music, dance, pantomime, and movies as visual poetry, often with an emphasis on body movement, Leng said. "The logo, with the head gracefully bent 90 degrees and leaning on an extended arm, is meant to capture the performers' fluid movements" and the emotional content of their gestures. "Rendered slightly offbalance, the letters suggest the style of the performers' movement." The arm extends unsupported by the type into the space, expressing the effort of the movement. And the curves to the right of the figure suggest the spare set design, often nothing more than fabric that sways because of the bodies moving near it.

Steam Films

Project: Stationery

Design Firm: Blok Design

Creative Director/Designer: Vanessa Eckstein

Designers: Frances Chen, Stephanie Yung

You've heard it before, but it's worth repeating and remembering: often what's simple is most effective. The designers wanted to express that creative moment (as if a boiling point) in which one state is transformed into another, so they chose a literal image to represent a film studio called Steam. The degree symbol at the end of the word suggests that a change in temperature is needed to change liquid to the company's name. A circular logo and die-cut note cards mimic the symbol.

The fluid type also seems appropriate. "Nothing in this design is soft and vaporlike, yet the...lowercase, rounded, cut-off type gives it a feeling of lightness without taking the boldness away from it," Vanessa Eckstein said. Then there's the blue: "Although blue seems to be the obvious choice for this identity, we chose three tones of blues as a way of expressing the process from the liquid to the gas state."

Numbers on some of the pieces reinforce the scientific associations with the name, in a multicultural way. On video and film can stickers, the boiling point in three measurement "languages"—Fahrenheit, Celsius, and Kelvin—hints at the company's international scope. Only one prints on the business card, alternating among the three measures and color tones.

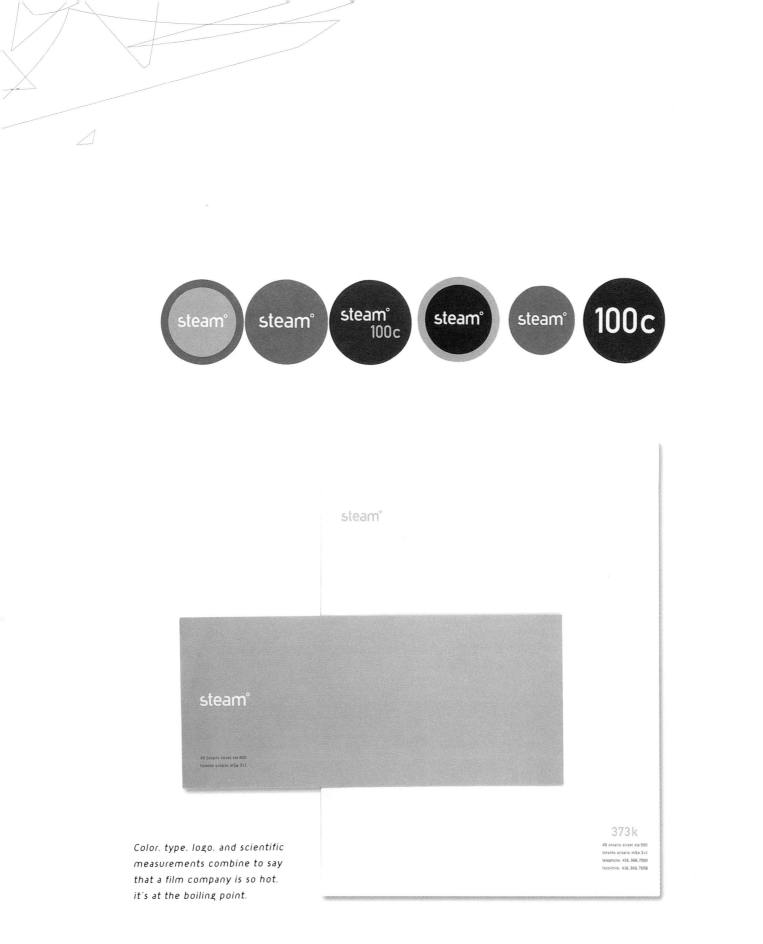

Color. type. logo. and scientific measurements combine to say that a film company is so hot. it's at the boiling point.

E.return

Project: Logo
Design Firm: Rhinehart Design
Creative Director: Morton Jackson, 4thought
Designer: Rob Rhinehart

See mark. see mark speak. see person in e holding box. The mark couldn't do more to simplify the concept of an online purchase-return service.

An online service was created to take the hassle out of returning merchandise bought from a participating vendor. Click a link on that vendor's page and a representative picks up, packs, and returns the unwanted item. That's a long story, told instantly and almost entirely by the company's boiled-down-to-its-essence logo: the negative space of the *e* becomes an abstract person with arms holding a package that's drawn icon-style.

"E.return wanted their logo to reflect ease-of-use and friendliness, and to suggest some sort of exchange," said designer Rob Rhinehart. All of that needed to come across from a tiny space on a Web page. Simplifying the mark to the style of an international symbol lets the logo read even in diminished size. The mark has a bonus: its clear simplicity transfers to the image of the company, suggesting an easy-to-use service.

Project: Logo
Design Firm: Lowercase, Inc.

*The e in the product name
doubles as a drinking cup, making
the mark meaningful even for
speakers of languages that don't
use the Roman alphabet.*

eSpring

Speaking of fun things you can do with *e* (e.return logo) and how
you can nonverbally convey water (or at least steam: Steam Films),
watch the versatile letter turn into a drinking cup. Here's why the
water-filtration system needed such a universal symbol. When the
client commissioned the identity, the product was sold only in Japan,
but Amway's strategy included marketing to other countries with other
native languages. The identity needed to be recognizable anywhere.

The designers knew the letter *e* would mean something in every
country whose language uses the Roman alphabet, but the cup shape
would mean something in all languages. You and every other member
of the water-drinking public get the connotation of the color.

Downtown Des Moines Farmer's Market

Project: Logo
Design Firm: Sayles Graphic Design
Designers: John Sayles, Som Inthalangsy
Illustrator: John Sayles

Plump tomatoes, bright carrots, peppers, and corn make it clear this logo is not selling software solutions. Not only do the graphics tell you it is selling veggies, they even tell you *where.* That comes across in the image representing a downtown skyline to the left of the farmer. And isn't he just everyman's farmer, from his cap to his plaid shirt and overalls. Although you can't see the logo on the cap—it's just a dot—you'd swear it reads "John Deere."

Naturally, designer John Sayles did the research on site. Many of the vendors who come to the downtown farmer's market look a lot like this farmer character, he said. "They're sun-kissed, older, and really personable and hands-on." Many of them grow their wares just for the market. With its hand-drawn type and interspersed produce, the logo was meant to portray the rustic feeling of the market. "It's kind of fun down there; [you'll find] big old plump tomatoes that come from the field in the Midwest."

Type becomes a vehicle for more visual meaning with the help of the farmer, produce, and the sun. He forms the *M* in "Farmer's," a carrot and its greens form the crossbar of the *F* and *A*, and that apostrophe's made from a hot pepper. Veggies also form the bullets between words and letters. The shining sun is near the center of town, posing as an *o*. The logo is a story told in four colors: warm orange, yellow, dark green, and black.

The plan for the summer is to screen print the logo on reusable burlap shopping bags made from old onion and potato sacks.

The farmer character—looking a
lot like the ones at the market—
and his wares grow into the type.

Fairfax Symphony Orchestra (FSO)

Project: Logo
Design Firm: JDG Communications, Inc.
Designer: Lisa Willis

On an orchestra's logo,
a baton appears to
rest after drawing the
acronym during a spirited
conducting session.

If a symphony orchestra came to you for a logo, a conductor's baton would likely be among your first ideas. Lisa Willis, FSO's logo designer, went there too, but she didn't *stop* there. Like the conductor the logo calls to mind, she followed through. The rendering of the acronym reads like a musical sign; better yet, it single-handedly mimics the motion of a baton.

Willis chose the color of the acronym as still another orchestral reference. The gold—metallic where possible, a CMYK build where it isn't—represents brass and woodwind instruments.

The Newton Chorale

Project: Logo
Design Firm: LPG Design
Designer: Chris West

Symbols of music and mourning merge in a logo for a concert in memory of a chorale director. Starting with the calla lily, a traditional symbol of mourning, designer Chris West drew inspiration for the graphics from early twentieth-century posters, and for the soft colors from contemporary designer David Lance Goines. The opening of the flower forms into a treble clef, while a sheet of music curls around the base.

Paul Chauncey Photography

Project: Identity program
Design Firm: Gardner Design
Art Director/Designer: Brian Miller
Art Director: Bill Gardner

Pull out the slogan. and the camera- and film-related images still tell you you're looking at a photographer's stationery.

Bill Gardner and Brian Miller were down to the wire on a photographer's identity elements. You may know how it is: "The client would be at our office in one hour and we had nothing designed yet." So the designers could show only one direction to the client, but it was enough.

"There is surely a lesson in this," Gardner said. The designers pleased their client because they quickly built on a foundation, and the firm's philosophy, of using the visual vernacular of the client's occupation. Although they didn't start drawing until the final hour, they drew on handy images they had been visualizing for three weeks.

On the fly, Gardner's approach was to use the everyday language of a photographer to support the logo they created. The designers recalled "the soft-edged blurry shadow" images they made as kids with photosensitive paper. They would cover areas of the paper with their hands and expose the partially shaded paper to the sun.

The colors of the stationery, cream and purple, also were inspired by their childhood photogram experiments. The large-format film edges are the instant visual clues that combine with the logo to convey the client's field. The designers extended the idea to a die-cut on the business card. The back of the card is like a negative, another image that cues to the world of photography.

The logo is whatever the viewer sees, Gardner said. Possibilities include the front of a camera with a shutter release wrapping around it; the initials *P* and *C*; the photographer's face looking left or right (one direction for the logo in positive; the other, in negative); a frontal view of the face with a big eye and a goatee.

Project: Logo
Design Firm: Suka & Friends Design, Inc.
Art Director: Gwen Haberman

BARRY GORDIN | PHOTOGRAPHY

A filmstrip forms an AIDS ribbon, an obvious visual reference to a photographer's support of research aimed at curing the disease.

When you have to combine two unrelated topics, familiar symbols work best. In this case, the concept of photography and AIDS care came together for an events photographer who donates a portion of his income to AIDS research.

"First I made a list of all the words and icons I could think of pertaining to the subject matter. That's always a good way to make interesting connections," Gwen Haberman said. The logo, in which a filmstrip bends into the shape and the color of an AIDS ribbon "kind of created itself." For the type, she chose elegant Minion Expert to convey quality work.

Richard Smith Photography

Project: Identity
Design Firm: Lowercase, Inc

So what if prospects have to go around in circles to get a London photographer's contact info? Anywhere it appears, the lens-shaped info announces his field, not just his location.

Richard Smith's approach to photography evokes the early days of the art. His treatment and choice of subject matter and his printing in sepia tones give his images an old, but timeless, quality, Scott Dvorak said. It made sense for the identity to do the same. The sepia-colored type curves into a camera-lens shape.

Project: Logo

Design Firm: Lowercase, Inc.

A photographer's initials work together to build an eye and a camera.

"The thing that struck us about Alison's work is her eye for detail and her ability to see things in a unique way," said Scott Dvorak. After playing with her initials, the designers found a way to combine them so the initials also suggest an eye, a camera, and maybe even the front legs of a tripod.

African Virtual University

Project: Logo/stationery
Design Firm: Neo Design
Art Director: Louisa Caragan
Designer: D.J. Min

The logo for a Washington, D.C.–based company that Web-broadcasts educational courses to Africa is called, appropriately, African Virtual University. The logo that represents it broadcasts its name and function. A digital map of the continent takes the name literally and figuratively. The circular pixels radiating toward the map capture the inward flow of digital information. The gradually increasing diameter of the pixels as they reach Africa makes plain that the movement is in, not out. And the logo's silver and blue are the time-tested colors of high technology.

Education for the Knowledge Age
Entrez dans l'ère du savoir

AFRICAN VIRTUAL UNIVERSITY
UNIVERSITÉ VIRTUELLE AFRICAINE

UNIVERSITÉ VIRTUELLE AFRICAINE INTERNATIONALE

Danielle Savard
dsavard@avu.org

www.uva.org

202...473.4458
202...522.7401 fax
P.O. Box 27715
Washington, DC 20038-9998

Lines of blue round pixels move toward a silver digital map of Africa to convey the concept of imported Web education.

Paysandú Natural Foundation (Uruguay)

Project: Logo
Design Firm: Interbrand Avalos & Bourse
Project Director: Carlos Avalos
Design Director/Designer: Guillermo Andrade
Designers: Carolina Lavista Llanos, Franca Piccolli
Production: Sergio Galeano, Marcela Schwarz

Fruit and the children who pick it are represented in this logo for an agricultural project.

Fruitlike colors are the first thing you notice about the logo for an agricultural project. That's appropriate, given the function of the foundation set up to provide work for children without families. Of course, you can't miss the *P*, the initial of the name of the organization and the city where it's based.

A green, curved shoot grows into the stem of the letter reaching toward an orange. The orange sends its shoots into a semicircle that symbolize extended arms for receiving and preparing the fruit. To the side of the green shoot, growing yellow circles represent the young fruit growing into the fully ripened orange.

The metaphor of the symbol refers both to the growth of the fruit and the development of the children involved in the project. In a way, it also says that those who take care of the fruit also are taking care of themselves, according to Diego Giaccone. The mark also has the look of a tropical bird, perhaps, you might surmise, a bird that eats the fruit and helps to spread the fruit seeds. Then of course, there's the idea of soaring above one's circumstances.

Hangtime

Project: Logo
Design Firm: Rhinehart Design
Creative Director/Designer: Rob Rhinehart

"Push as hard as you can, go as high as you can, and look good doing it," sums up the "ultimate goal of all extreme sports," Rob Rhinehart said. He used that understanding to design a logo for a maker of clothing for the x-sports such as snowboarding, skateboarding, and surfing.

The company calls its product "air wear," to describe their product line, which is "targeted towards those who pursue the few seconds of time spent off the ground, ignoring the laws of gravity," the designer said. Along with alluding to the thrill of being airborne, the name "Hangtime" also suggests hanging out and looking cool...musts to the eighteen- to thirty-year-olds who are drawn to the sports, he added.

The mark hits both references. Rhinehart explains: Either the guy's head is in flames, or it's "just his hair being whipped by the wind as he sails through the ether. Either way, he's so cool doing it that he hasn't bothered to take off his shades. This is his moment...he's on fire." And he's doing his burning on the upside-down triangle used in warning signs to "reflect the risks involved in pushing your limits."

Not dangerous enough for the audience? The logo does still more, suggested the artist: It's reminiscent of the icon for toxic waste...a kind of ironic visual pun on the dangers inherent in getting "good air." The design manages to look controlled and excessive at the same time, reflecting the coexisting yet contrasting mind states of the athletes (who probably don't care much for that term).

Gravity defiance. danger.
and contrasting states of
mind—cool/hot. controlled/
full-throttle. The maker of
extreme sportswear says it
all in one mark.

American Library Association (ALA)

Project: Logo
Design Firm: Neo Design
Designer: Louisa Caragan

Flash goes the photocopier as it makes a copy of a book's page. The flash looks almost comic-booklike, printing yellow behind the black book that's shown spread open, pages splayed, on a flat surface. Louisa Caragan designed the logo for the ALA's campaign to protect general readers' right to photocopy books for personal reference. The logo was turned into stickers, bookmarks, and more.

Showing just enough book detail to make the logo clear. the image helps to approve book copying under certain conditions.

Yellow Pages

Project: Logo
Design Firm: Mires Brands
Creative Director: Jose Serrano, Brian Fandetti
Designer/Illustrator: Miguel Perez

™

*To reposition Yellow Pages
telephone directory as a place
to look for ideas, not just phone
numbers, Mires replaced the
familiar walking fingers with
a lightbulb. With such a
recognizable logo, it wouldn't
have made sense to start
from scratch.*

D.C. Public Library

Project: Logo
Design Firm: Beth Singer Design

A variety of logo studies put people and resources together, symbolizing the job of a library. You can see the designer experimenting with various focal images.

Multiple audiences of the client mean multiple challenges for the designer. The primary audience of the public library that needed a logo is the entire population of the District of Columbia, comprising the range of age, education, and socioeconomic levels. Beyond that, there were secondary audiences to consider.

And the logo had multiple messages to convey: the variety of print and digital resources and the friendly community atmosphere offered by the library. Singer presented a series of studies showing people interacting with books or computers. Ultimately, the client decided that the resources alone were enough work for one logo to do. The resources had priority because they were more important to the library's public-relations campaign.

Put the focus on the resources, asked the library. The second group of logos refined the logo chosen by the client (upper left). This series shows print and digital resources in equal measure.

Here's the final version, in color.

Latina Magazine

Project: Logo
Creative Director/Designer: Irasema Rivera
Designer: Juan Padilla

A shape of a logo announces a magazine's fifth anniversary. Dividing it in half (by the number's shape) reflects the dual cultural backgrounds of the magazine's readers.

The process to create a logo to commemorate *Latina* magazine's fifth anniversary began with one primary visual parameter. The logo should be graphic, but not too immediately obvious. Irasema Rivera found inspiration in a star used on a card that holds the magazine's mission..."bingo, five points, five years."

But Rivera really didn't want to use a star. Sketching brought her to a pentagram, a strong geometric shape with five sides as well as five points.

"I used the five to carve the shape into two pieces, slowly getting away from an obvious number and focusing more on the two halves," Rivera said. The halves are meaningful because "our culture as Latina has two halves, the Latina and the American."

The designers chose blue and green because the colors have "positive spiritual value. Green often is associated with creativity and energy; blue, with calm and serenity." They made the color vibrant as a reference to Latina art, such as that of Frida Kahlo.

Columbia Lighthouse for the Blind

Project: Logo
Design Firm: Mek-aroonreung/Lefebure
Designers: Pum Mek-aroonreung, Jake Lefebure

It doesn't take a search engine or a nautical beacon to find the only appropriate symbol for a nonprofit group that has "lighthouse" in its name. So the obvious appears in its logo. The greater information graphics challenge arose when the designers were asked to build a logo for the group's centennial. The designers created that mark simply by making the lighthouse double as a "one," and shine its beam through the zeros in "100."

169

You gotta use a lighthouse and nothing more for the logo of a group with that word in its name. But in the centennial logo, the icon works overtime to also make like a century.

Sports Pick

Project: Identity package
Design Firm: Amoeba Corp.
Designer: Michael Kelar

Sports Pick makes gaming kiosks located in licensed establishments. Its identity needed all the typical applications, along with the need for computer animation. The client asked for something that communicates directly and boldly, so the viewer would "read" sports, action, and interaction.

The symbol itself has a duality of meaning. More obviously, the diagonal object looks like a human form running through center court or over a base. Less obvious, the object doubles as a hand interacting with a button.

It's a Wonderful Life Productions

Project: Logo
Design Firm: Thumbnail Creative Group
Creative Director: Rik Klingle
Designer: Valerie Turnbull
Producer: Judith Austin
Illustrator: Randall Watson

A logo for a community-minded production company recalls the days when "click" was what you did with heels. not with computer keys.

As its name suggests, a media production company called It's a Wonderful Life Productions focuses on positive community-oriented projects. So its logo had to reflect that focus. The designers also knew that, because of the work of the company, the logo had to work both animated, for film, and at "rest," for stationery.

Meet the happy guy the artists conjured up to fill the roles. In the animated version, he walks along (no doubt whistling) until struck by an impulse to jump up and click his heels together. His left hand holds on to his hat; the gesture also could be interpreted as tipping the hat in a friendly greeting. The still version freezes the moment when he kicks up his heels.

The character's fedora, even the cut of his suit and his shoes place him in the decade of the company's namesake film. The icon is a visual summary, not only of the production company's philosophy, but also of its president/producer, Rik Klingle said.

Illustration—as it sounds—illustrates, simplifies, and enhances often-complex concepts. It's a form of visual editing, boiling down a concept to its essence, translating that essence into graphics, and subtracting everything that doesn't contribute. That task is the same for every illustrator and every project.

But illustrators come to the task with different backgrounds and philosophies, which show in the product. Designer/illustrator Slavimir Stojanović has a name for his philosophy (and the magazine he founded). Futro, a merger of "future" and "retro," describes his "way of thinking and living a creative life no matter what circumstances surround you." He has tested the philosophy, having developed it while he was growing up in the war-torn Balkans.

Chapter Four

"The city of Belgrade, once a cultural and economic center of the region, became a black hole of Europe, where suddenly global tendencies became irrelevant," recalls Stojanović. In response, local creative talents turned to using universal symbols in unexpected ways, "playing with the context and meaning to get the messages across."

"Symbols are free of charge (important where budgets don't permit hiring photographers), everyone understands them and the ideas are more precise," Stojanović wrote. In a region with the Balkans' history, symbolism wields even more weight: "People were trained to understand symbols and symbolic political speeches. But once you change the context of a symbol, new qualities emerge. Visual communication becomes more complex, intriguing, and entertaining. People start thinking more about the concept once they decipher the basic message."

Here's some illustrative food for thought, from Stojanović and other thinking illustrators.

The New York Times asked for a visual reaction to the attack on the World Trade Center towers to run the next day, Friday, September 12, with a story: "Fighting an Elusive Enemy."

The idea came from the strong image of the two instantly familiar rectangles that were in the New York skyline. Designer Ivan Chermayeff recognized that they can be represented by the two strokes of the capital *U* in "U.S." By tearing them off, the U.S. still remains legible without them. In another way, Chermayeff said that their removal makes clear that this terrorist attack was not just against New York and Washington, but against the United States of America. The *Times* liked the image enough to hold it for use in the more widely read Sunday paper.

Publikum

Project: Calendar
Designer/Font Designer: Mirko Ilić Corp., New York
Concept, Creative Production: FIA Art Group, Belgrade/New York
Creative Director: Stanislav Sharp, FIA Art Group
Project Coordinator: Nada Rajicić, FIA Art Group
Handlettering: Mirko Ilić, Ringo Takahashi, Ryuta Nakazawa,
Asa Hashimoto, Jelena Čamba Djordjević
Illustrator: Slavimir Stojanović

This project doesn't really fit into the identifying format that I've used everywhere else in the book; in fact, it defies categorizing (and description in just a few paragraphs). The calendar (for lack of a more apt label) is the millennium version of an annual series from Publikum, a Belgrade publisher and printer. Called "Antiwall," the piece "promotes a vision of the world without walls and boundaries," according to FIA Art Group. The political/social statement oozes with visual meaning.

The calendar slides out of a box that looks and opens like a book, appropriate because it's a collection of art as well as a history. Each calendar page features a captioned piece from one of a dozen internationally recognized artists, including Björk, David Byrne, Christo and Jeanne-Claude, Oliviero Toscani, and Tadanori Yokoo.

The left "page" of the "book" counts off 2001 years with 200 slashed groups of hand-drawn hatch marks plus a solo. An actual book is glued to the right side. It contains introductions, brief bios of the contributing artists, an illustrated history of the calendar series, and—most challenging—thirty-five highlights (and "lowlights") of the almost 2000-year history of the Serbian people. This feat is accomplished in only four pages by numbered bilingual captions, with correspondingly numbered pictograms by Stojanović.

Type for the entire project is hand-lettered in the manner of old monastic manuscripts to reflect the handmade aspects of the project with a run poetically limited to 2001 copies. The hand-lettering also is meant to soften the look of the type. It took five artists to do the lettering on the project, which contained more type than Mirko Ilić anticipated.

Ilić created similar-looking typefaces for both languages: In the Cyrillic face, called "Chiffrilica," numbers replace letters in some cases. That's to suggest that Serbs must "now pay more attention to numbers, the language of time, money, and economy. They must be more calculating and less emotional," as he wrote in the creative notes in the book. The English face, which the designer named "Englic," combines Roman characters with a few Cyrillic-looking ones.

Some of the book prints in glow-in-the-dark ink as a tongue-in-cheek aid to Serbs who are "still trying to find a way out...of the Dark Ages," Ilić wrote.

A calendar is called "Antiwall" because it sought to tear down political and cultural walls. The enormity of that challenge may be reflected in the fact that the calendar's removal and assembly are so complex. it came with instructions. The calendar on the right scored and folded in half to fit inside the opened "book" box. On the left of the open "book," the years (A.D.) leading up to the current one are shown without words. On the right. an actual book contains contributors' bios and more. Upper left is the closed "book" box.

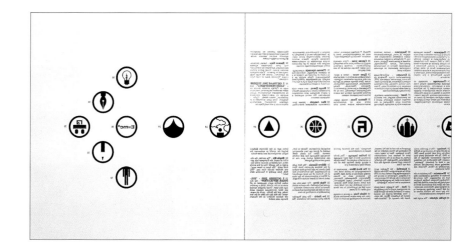

The book glued onto the box that encloses the calendar gives the Serbian history in numbered universal pictograms and correspondingly numbered bilingual captions.

Mount Sinai Medical Center, New York City

Project: Patient communication tool
Design Firm: Poulin + Morris
Designer: L. Richard Poulin
Research: Ruth Ravich
Concept: Linda Marks

Icons are no strangers to medical contexts, like the universally understood skull and crossbones. Here's a set of icons whose instant nonverbal communication is designed to help to save lives, improve medical care, even reduce frustration.

The Patient Representative Department of Mount Sinai Medical Center asked Poulin + Morris to design a tool that would ease communication between speech-impaired patients, their families, and hospital staff. Each of two versions of the gloss-varnished Communi-Card measure $22^3/_4$ inches by $13^1/_2$ inches unfolded.

Clear pictograms on the front of each card illustrate symptoms and medical, physical, and emotional needs. Others represent specific health care specialists whose presence the patient may want to request. A patient can simply point to the appropriate one.

For example, the valentine-heart in the chest of the person diagram suffers such symptoms as a sharp pain (a lightning bolt), sticking pain (pins), and burning (flames). Clock icons let patients indicate the symptom's duration: short (shading over ten minutes) or long (shading over forty minutes), constant (an uninterrupted circle around the clock), or sporadic (an unevenly dashed circle).

Head-only icons communicate fatigue, unconsciousness (same as tired except that the head is horizontal), and dizziness, nausea, and shortness of breath, among others. The guide even graphically handles such requests as lowering or raising the bed, or turning the patient.

An alphabet on the back of the first Communi-Card lets the patient spell out a word or more, and a drawing of the human body permits pointing to the location of a physical problem. The card also contains simple, one-word questions in English and a second language, Spanish, Russian, or Japanese.

So even patients who don't have speech impairments but who don't speak the language of the medical staff can benefit from the tool. Because immigrant children tend to be the first to learn the second language, they often have been relied upon to translate for their relatives, the patients. That's a system that can be dangerous for the patient and traumatic for the child.

The tools can help relatives communicate when there aren't enough professional translators on duty (another improvement introduced by many hospitals), or staff members who speak the language of the patient. At the beginning of 2002, the cards were in use in more than 150 hospitals and health care facilities in the United States and Canada.

Icons that represent symptoms and needs help patients communicate. whether they're speech-impaired or they speak a different language from their health care providers.

Burton Snowboards

Project: Instruction manual
Design Firm: Interrobang Design Collaborative
Art Director/Designer: Lisa Taft Sylvester
Illustrator: Richard S. LaRocco

Burton Snowboards' line of snowboard bindings is marketed globally. So the products' instruction manual was designed to be accessible cross-culturally, without language translation—the company's other materials typically get translated into six languages. The manual uses only pictures and numbers to show how to use the product.

The piece accordion-folds and prints on both sides. It's attached to the binding through a hole punched in the upper-left corner of the folded piece. The customer has to remove it to use the binding.

Watch how clearly this piece speaks without words: if you're a snowboarder, you can "read" the artwork without reading the lay "translation." A lot is clear even for nonsnowboarders, but I still checked with Mark Sylvester just to be sure.

Sylvester explained each step, and also that "beginners will most likely not leave a snowboard shop with the dealer setting these adjustments for them, so these manuals cater to intermediate riders...but newbies have responded well to the visual aspects, too." He also mentioned that the instructions are easier to follow with the binding in your hands.

Black ink is used for the pieces, red for the instructions—arrows, measurements, and "sound effects." The first two circular panels show what came with the binding (attachment pieces) and what tool the buyer will need to adjust the bindings (a #3 Phillips-head screwdriver).

The next panel shows the optimum distance between the SlapRatchet and the binding when
the foot is in the binding. The X-ray of the foot makes that part clear. The red marks over that
aerial view also shows where the wearer should feel the pressure from the strap. The lack of
snowboard in this panel communicates that it's best to make the adjustment before putting the
binding on the board.

The board does get involved in panel 4. The red ink here tells all this: the space between feet
when attaching bindings should equal the distance between the top of foot and the kneecap.

The next panel 5 shows how to use the discs and hole patterns to set up the bindings on the
board, and the next gets even more specific and close up. It also warms against the use of
LockTite drops, which ruin the nylon inserts on the screws, according to Mark Sylvester.

Panel 7, the first one on the manual's flip side, shows how to unlock the adjustment on the
binding. The next depicts its three adjustable positions, with the most forward-leaning one
in panel 9. The next one locks in the adjustment; panel 11 shows the recommended angle
adjustments and forward-lean position relative to the board's edge. In panel 12, adding or
removing a plug adjusts the rigidity of the position.

The final panel illustrates the sound of the strap release with bursts and words, old-fashioned-
comic-book-style.

Seiko-Epson

Project: Icon design for LCD projectors
Design Firm: Design Machine
Creative Director/Designer: Alexander Gelman

Test your understanding of video and the universal language of icons in these designs from a projector's control panel. Left to right, top to bottom: computer input, mute, menu, freeze, volume, video input, cancel effect, power.

On previous models of LCD projectors, functions on the control panel and remote control printed in seven languages. To eliminate all the verbal language on models still in development, Seiko asked Design Machine to come up with a visual language, creative director Alexander Gelman said.

The words are just as abstract as the visuals. As in the binding manual, the icons require no linguistic translation; in a few cases, they require minor understanding of the field described. Here are eight of the twenty icons in the system.

Village Voice

Project: Illustration
Art Director: Minh Uong
Illustrator: Mirko Ilić

A raised fist among the computer-icon pointing hands—all appropriately bitmapped —illustrated a feature article about the left-wing gaining influence in the otherwise right-wing Internet. The article title: "Take Back the 'Net."

Magma [Büro für Gestaltung]

Project: Book
Art Directors: Lars Harmsen, Ulrich Weiß
Designers: Sandra Augstein, Ralf Christe, Patrick Grossien,
Isabelle Göntgen, Boris Kahl, Sabine Klein, Verena Mildenberger,
Chris Steurer
Photographers: Sandra Augstein, Christian Ernst, Lars Harmsen
Copywriters: Lars Harmsen, Rieke Harmsen, Chris Steurer

The employees of the German design firm Magma [Büro für Gestaltung] refresh themselves at lunchtime by talking, not about business, but about politics, art, and personal experiences. Some of those conversations evolved into chapters of a book the firm created to send to its current and prospective clients.

The firm found it interesting to work on a noncommercial project "where you don't have a client asking you for something." It was conceived to show the firm in a way most of its clients don't see, "not to shock, just to say: 'look, we are able to think'" and design differently, said Lars Harmsen, a principal of the firm. The book is "critical, often satiric; a lot of the stories deal with fear." Bound into it is "a patchwork of many different ideas, the cultural output of a generation." The designers hope it will result in new clients and projects that offer more creative freedom.

The book is called *am rande* (which translates to "on the edge"), a collection of illustration- and photo-packed chapters. One chapter, "on the edge of good taste ("des guten geschmacks"), visually and verbally explores how cultural background affects one's interpretation of images. Photos include designs cut into skin, which signify protest, criticism or self-destruction in the West, and status and decoration in some other parts of the world.

Another chapter, on the edge of the universe ("universums") looks at the strange worlds outside our planet and in it, universes within the universe. For example, it shows photos of the wall separating East and West Germany (two universes in one world); and scenes from Big Brother, the TV show that puts strangers into a house together for one hundred days, and "one by one, they kick each other out. The one who lasts is the winner...an edge. Stupid and crazy and funny," Harmsen said.

Other chapters focus on catastrophes, legibility, society, strain (exploring how far things can go before they burst), and truth (a legend about the firm that it invented for the book; the employees dressed up in period costumes for the photos). Madness ("des wahnsinns") is the most universally understood chapter. It packs one page after another of meat packages, the kind you get in the market. But instead of a slab of beef, it's the poor creature destined for the meat case that appears in the shrinkwrapped tray.

RINDER ROULADEN

18.11.2001

GRUNDPREIS
11,99 DM/kg
6,13 EUR/kg

GEWICHT
0,409 kg

PREIS
04.88 DM
2,67 EUR

MAGMA
76185 KARLSRUHE

The designers created the story in the summer of 2000, six months before the first registered case of Mad Cow disease in Germany; then they altered it. "First we had just the portraits of all those cows...wonderful animals! Putting those lovely cows in the meat packages was a nice way to say: 'Hey, look what you are eating when you eat a cow.'"

By the way, here's a sanity-saving technique that might work for you: Magma installed a big ship bell in its office to help designers cope with intense, long-term, or boring projects. "Each time such a project is finished, the responsible designer rings the bell."

Art Directors Club of Metropolitan Washington

Project: Illustration for membership brochure
Design Firm: Michael Gibbs Illustration and Design
Illustrator: Michael Gibbs ©2001

An art directors club membership brochure contains minimal text, with each page a full-bleed visual interpretation of a membership benefit. Each participating artist was asked to illustrate a single word. Michael Gibbs chose "sharing," then illustrated it by showing the opposite of sharing: one dalmatian with a coat filled with spots, the other with just one spot.

(I've got to admit my take on it when I first saw it: that it illustrated sharing because the spotty dog was beginning to give, if not the shirt, then a spot off her back.)

Gibbs likes to illustrate certain 'human' traits with animals. He explained that relating the trait to an animal lets viewers focus on that one trait. An illustrated person might distract viewers to think also of other human traits, including negative ones like jealousy and discrimination.

The single spot on the sitting dog defines the picture. More than one spot and the message would be diluted, and no spots at all could be 'read' as a different breed rather than a dalmatian that didn't have enough, Gibbs said. More important, it wouldn't deliver the message of sharing.

"The idea of a single spot becoming the focus of a page is one of those early art-school lessons. Sometimes very basic principles of art, design, and visual phenomena are the ones best exploited, because they're universally understood."

Before settling on dalmatians, Gibbs auditioned other animals for the part; any animal with a pattern would have worked. The next decision was how to approach the sharing theme: to show them sharing, or to show them not sharing, and either approach would've worked. Showing an opposite situation to prove the reverse also is a well-known design strategy.

Gibbs originally had the dogs in the same pose you see, but with a different pattern: He depicted both dogs spotless except for where they overlap. But the pattern wasn't strong enough to convey the message instantly. And having them not sharing creates more visual (and therefore conceptual) tension between the "haves" and the "have nots," making it a much stronger read and visual presentation.

The image works in part because everyone knows what a dalmatian looks like, especially because he included a "normal" one. (Without it, the mono-spot dog might be read as some other breed.) The recognition factor points to the moral of the story: that the spotted dalmation could share many of his spots and still be a dalmation.

An illustration in a membership
brochure depicts sharing. a member
benefit. by showing its opposite:
A dalmatian that's well endowed
with spots doesn't share with his
poorer buddy.

Approaching the end of every year, you reach designers' paradise...you can design anything you want. Your holiday greeting to clients and prospects is your chance to strut your stuff without client intervention. This is cause for celebration, right? Then why do so many designers tremble at the thought?

Well, no one said it's easy to distill all of your clients—the ones you've got and the ones you hope for —into one crowd-pleasing design. It can be tough enough to satisfy any given client at a time. So it's no wonder that designing a holiday greeting for your own studio is a task of almost-paralyzing proportions.

It's a delicate balance: a holiday card has to show off your creativity without a hard sell, or even a soft one. That means no more than employees' names and a company name inside, with a return address on the envelope. Recipients tend to frown on even a phone number or a Web address at this sensitive time of the year.

holiday greetings

Chapter Five

What is welcome is imagination; graphics that convey gratitude for the association, and friendly, warm feelings in general...maybe some gentle, inoffensive humor. Let's face it: the goal is for your recipients to open the envelope or the box, and be delighted, associating that delight with the fine design firm that sent it.

What's more, your greeting probably has to appeal to a multicultural audience. For that reason, many companies have moved away from a Christmas message to one that is nondenominational. An alternative is to design a message for each culture's holiday, but that's a sticky wicket, not to mention an expensive one. Some designers manage to take a universal approach with one mailing. They do it, not with what they leave out, but with what they add: greetings in various languages or cultural symbols.

The holidays give us extensive iconography to choose from. Although you'll see most of the usual suspects in use in the greetings in this chapter, you'll see them in novel circumstances. Same thing with colors: Rudolph red, holly green, and snowflake white may be in attendance, but only as a point of departure.

You'll also find holiday cards that went beyond the typical greetings to express the year's theme. Many holiday messages in 2001 showed the influence of the terrorist attacks four months before. Those include some of the holiday cards designed for clients to send to their clients. In the client-to-client category, the same rules apply, with some of the heat off, and the constraints on.

PPI

Project: Holiday card
Design Firm: The Marlin Company
Designer: Matt Rose
Illustrator: Linda Fountain
Copywriter: Judith Garson

The terrorist attacks of September 11, 2001, stayed on the minds of clients and other designers as they created that year's holiday greetings. PPI, a product and packaging firm, sent a mandate for a card that included a sense of patriotic unity along with the traditional holiday wishes. Reindeer, who team up to deliver Santa's toy-packed sleigh, were a natural to also deliver a "Let's pull together" message with a holiday spin.

Patriotism is right on the nose, but it takes opening the card to get it. The cover on the five-panel card shows a reindeer with an expected Rudolph-red nose, with radiating marks to suggest its shine. The payoff comes inside when the same nose turns to white on the second (inside cover) panel, then blue on the third. The verbal punchline appears on the last two panels.

The company must have recalled their fun with paper-cutting two years before (see the holiday-concert poster on page 61). Linda Fountain did the paper-cut illustration of the reindeer. The card is printed on cardstock called Curious that has metallic flecks embedded in the sheet. Here it suggests winter, snow, and ice crystals.

The red-nosed reindeer image on the cover suggests nothing more than a holiday card: inside a deeper agenda is revealed. The nose of this pulling. team-working creature turns white. then blue to call for patriotic unity after a tragedy.

Vulcan Ventures

Project: 2001 holiday flip book

Design Firm: Hornall Anderson Design Works, Inc.

A holding company wanted something that would be more memorable to its recipients than just another corporate holiday card. So the designers came up with this whimsical flip book. It also evokes memories of what people used to do for animation in the days before Flash, or even Looney Tunes.

Flip the pages front to back, and you see a small figure sliding down and off a snowy hill, into the words, "Wishing you a great ride." The image shifts to the right by about an eighth of an inch on each successive page. Flip from back to front, viewing the left-hand pages, and the words "Here we go again" appear, then move out of sight, as the tiny scarf-wearing slider drags the toboggan back up the hill for another go. To keep from interfering with the motion, the logo appears only on the back flap.

This feat of animation is accomplished on the eighty-four-page, pint-sized (4-inch by 3-inch) book in just two colors: icy metallic blue with black outline drawings. This piece is meant to be kept throughout the year, as opposed to being discarded like most holiday greeting cards.

Flip through the pages of
the book and see the tiny
figure sliding down the hill.

Flip it back to the front
and watch the left-hand
pages this time, and you'll
see the sled and rider go
back up the hill.

IE Design

Project: Holiday card/playing cards
Design Firm: IE Design
Designers: Marcie Carson et al.
Illustrator: Cya Nelson

Bored with the typical holiday card that "folds in half and sits on your receptionist's desk," the designers thought instead of fun and games. The challenge they gave themselves: create a holiday pack of playing cards as a way of promoting family time, relaxation, a game of Go Fish, and of course, themselves.

They did it with an illustration of a toy on each that relates to the face of the card. For example, an airplane represents the ace, a tricycle for the three, the queen looks a lot like a Barbie doll, and eight is a jump rope arranged in a figure eight. The joker is a couple of jack-in-the-boxes, so jacks and a ball can be reserved for the jack card. The holiday mailer gets across a lot of messages: It suggests card games and other games, and warm holiday wishes. At the same time, the toy illustration on each card graphically communicates the card's value.

A folded title sheet that shows through the window of the cardboard card box is printed with a pattern that looks like a personal check. Each member of the design firm signed the inside. The title is typeset in an old-fashioned script, recalling the days when families regularly stayed home and play cards together. A few halftone jacks preview the toy theme at work inside the deck, while a circular chart listing playing-card labels and suits gives further hints that what's inside is a deck. A retro-looking curvilinear pattern on the back of the cards reinforces the old-fashioned, family-values theme.

Remember when our priorities for the holidays were to play with our friends, eat hundreds of cookies and fill out our wish lists? As the years past, we replaced our dolls with cell phones and traded in our yo-yos for fax machines, but the magic of the season still reminds us take time out to play. In the midst of the hustle and hustle this holiday season, we at IE Design hope you find the time to relax with your friends and family to enjoy a game of cards.

Holiday GAMES

Brought To You By
THE FRIENDLY FOLKS AT
IE DESIGN

A design firm decked its clients' mailboxes with a deck of holiday-themed playing cards in which the design firm promoted family time. relaxation. a game of Go Fish. and. of course. themselves.

344 Design, LLC

Project: Poster
Designer/Illustrator: Stefan G. Bucher

For his New Year's greeting poster, designer Stefan Bucher's goal was to "deal with all that had happened during the year, yet keep it positive and hopeful." He designed a grid of 2200 numbered circles, each representing a year. The last circle contains an arrow to convey a "continued" message. A loupe zeroes in on the current year among many.

Bucher's initial concept was "a Ralph Steadmanesque drawing of chaos and confusion on the left of the poster that would resolve itself toward a single line on the right, leading to a simple 'Happy New Year' greeting." A pencil would mail with each poster for continuing the line according to each recipient's hopes for 2002. Two problems with that idea: "I'm not Ralph Steadman and I can't afford to hire Ralph Steadman."

Next, the designer realized that although many people couldn't wait for 2001 to end, they also feared what might come next. He thought of a postcard to say "Happy 2003" and "344: The Future Today." But "what's a year? If you're going to travel to the future, travel! So I thought, oooh, what about 2202...or even further ahead? Then the concept got a bit muddled."

While working on clarifying his statement, Bucher saw a news program that debated the significance of 2001 as it might be viewed from future decades. "That's where the final poster thought came from. The idea is that every year, no matter how dramatic it is at the time, is just one year among thousands. The year that matters most is always the one you're in. It's the present year that gets the full scrutiny. Hence the loupe."

The display of years lets viewers seek out past ones that are important to them, to notice their physical distance from the current year, and to daydream about the future. It also gave Bucher a clever way to plug his company's name—a number—by printing it positive, black on white... different from the other numbers.

Bucher also called attention to the company name by strategically positioning the two tiny greetings ("Every year is better for having you in it" on the upper right and "Have a safe and happy new year" on the bottom right) as subtle navigational guides. Using them as starting points from which to travel along the horizontal and vertical dot axes, they meet at the company name.

The designer "wanted to do a quasi-Japanese poster, something that would work as a formal, almost abstract exercise. I started with the annual dots arranged like a flowing river, getting bigger toward the foreground, which looked a bit forced." So he went with the grid of same-sized dots you see.

What you probably won't see on the reduction, to the left of the loupe, is the word "Welcome," printed only in clear gloss varnish. "I like putting in details for people to discover as they live with the piece a little...much like (those in) the background on *The Simpsons*. I think Matt Groening calls them 'Thank-you-for-paying-attention details.'"

A visual depiction of one year among
thousands puts time, and one year's
events, in perspective on a designer's
New Year's greeting poster.

Ergonomidesign

Project: Christmas card

Magic Flyer Manufacturer: Novapolis, Inc.

*Open
and let the
Christmas spirit
out...*

*A holiday greeting
arranged in the shape
of a Christmas tree
drops only a hint of
the surprise inside
the card.*

You know the feeling you get when you open an envelope that gives every indication of holding a Christmas card. It's more like mildly pleasant anticipation than heart-racing excitement. But the recipients of Ergonomidesign's 2001 card opened up to a shock.

The experience started off typically enough: The flap of a snow-white square envelope lifted to reveal a simple gray star. Slide the card out and the star is revealed to top a Christmas tree made from the red-printed words "Open and let the Christmas spirit out." So you do.

Whoa…something bursts from the card, spiraling, soaring up while making a sound like compressed air released quickly. You gasp and search for the escapee when it lands. It's a tiny self-propelled, stringless paper missile called the Magic Flyer, a patent of Novapolis of France. The butterfly is made from thin paper that's attached to a fine wire frame joined by a rubber band. Twisting the upper wings ten to fifty times while holding the bottom part creates tension in the band. Sliding the high-pressure piece into the card and its envelope arrests the climax until it's released, an ideal reflection of the words on the card's front. In fact, the one I got held so much energy struggling to get out that it left an embossed impression on the card.

The band of the Magic Flyer twists to harness the energy that lets the butterfly soar. The colors and patterns suggest winter and a tool of the industrial-design firm that chose them.

God Jul
A Merry Christmas

&

Gott Nytt År
A Happy New Year

ergonomidesign

Malin Orebäck, Maria Benktzon, August Michael, John Grieves,
Håkan Bergkvist, Anna Carell, Olle Bobjer, David Crafoord, Daniel Eriksson,
Elisabeth Ramel-Wåhrberg, Hans Himbert, Björn Torhall,
Daniel Höglund, Oskar Juhlin, Sven-Eric Juhlin, Kristina Liljedahl, Thomas Nilsson,
Ulrika Ewerman, Pelle Reinius, Krister Torssell, Ulrika Vejbrink, Mattias Rousk,
Jonas Fridholm, Marcus Heneen, Stefan Strandberg, Birgitta Sundén

The inspiration: The year before, a member of the Ergonomidesign team had received a butterfly, a yellow one, more like the standard ones shown on the Magic Flyer home page, Daniel Eriksson said. "We liked the surprising effect, but we wanted to avoid the summer connection of a butterfly. Therefore, we made it look more clean and wintry," using white, silver, and red.

The silver, gridlike graphic on the wings has dual meanings: it reflects the fine, subtle structure in a butterfly wing, while it refers to the work of the industrial-design group. It's an effect like those created by one of the firm's commonly used tools: 3D-CAD modeling.

The text on the card's front also lends the potential for surprise. The Christmas-tree shape is subtle, so the designers estimated that some viewers wouldn't recognize it at first glance. One other nonverbal message: a friendly-looking photo of each employee replaces signatures. They fill the panel, as if filling a room with holiday cheer.

"We have a twenty-year-long tradition of making our own unique Christmas cards. We always want to surprise, make something happen and encourage the receiver's own creativity in a pleasurable way," Eriksson said. Last year, for example, the firm sent a sheet of temporary tattoos of some of its product designs, done up for Christmas with boughs, bows, stars, and holly. The year before, it sent a tiny watercolor box with eight colors, a brush, and a sheet of watercolor paper embossed with the firm's previous identity.

Bridgetown Printing Company

Project: Calendar
Design Firm: Dotzero Design
Designers: Karen Wippich, Jon Wippich

Another calendar in the "month-of-the-month club," from a printer, included a metal stand laser-cut with the printer's name and phone number. Each month's calendar, designed and folded to straddle the stand, is mailed separately.

The calendar features retro photos that play with secondary meanings of its theme, printing terms. For example, 50s graphics of a TV dinner illustrate "direct to plate," which any savvy designer knows as a reference to a computer file's transfer to the printing plate. A photo and diagrams of bowling referring to the "gutter" are shown as a no-strike zone for headlines and photos, not just the ball.

More? "Press check" is conveyed through a photo of nuns at work with their irons; "ghosting," by the ghostly image of a girl, this one for the month that has Halloween in it. And an old-fashioned bathroom scale symbolizes and explains the "heartbreak" of dot gain.

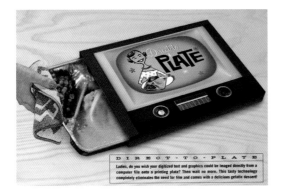

Press Check

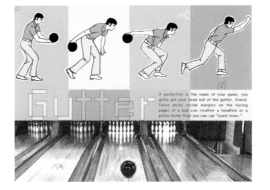

Retro images representing
the primary meaning of terms
used in printing help to define
the jargon on a printer's calendar.

In-Sync

Project: Christmas card

Design Firm: The Riordon Design Group Inc.

A system of icons categorizes each gift idea as being experiential or tangible, or having the personal touch.

It makes sense for a marketing analysis/research firm to talk about visions. For the firm's holiday card, Riordon Design drew inspiration from Clement Moore's classic poem to connect marketing visions with the ones that dance in heads at Christmas.

Silver holiday icons dance on the card's sparkly cover and a silver sticker seals the curvy flap. A question mark on the sticker teases recipients to look inside. There, drawings depict the dreamer as a mike-wielding diva, a yogi, and a racecar driver. A key and a window do their nonverbal parts as metaphors for a key to unlock the visions, a window into the mind (or something like that). And the cover icons turn up again floating outside the head.

The drawing delivers viewers neatly into what follows: A pullout guide of gift ideas for fifteen customized (audience) profiles to represent "those special people in your life." For each profile, the guide offers three to six gift ideas, each helpfully labeled with an iconic code to categorize it. A swirl identifies gifts of the experiential variety; a flower represents those that are tangible; and a hand represents gifts with a personal touch.

The diva, the yogi, and the race car driver icons turn up, with their own profile. For example, there's Minivan Mario Andretti. Some of the other profiles also get illustrations, like the future astronaut, a kid in propeller beanie riding an upright vacuum cleaner. The card comes off as amusing, useful, and appropriate for the image and the business of the firm that sent it.

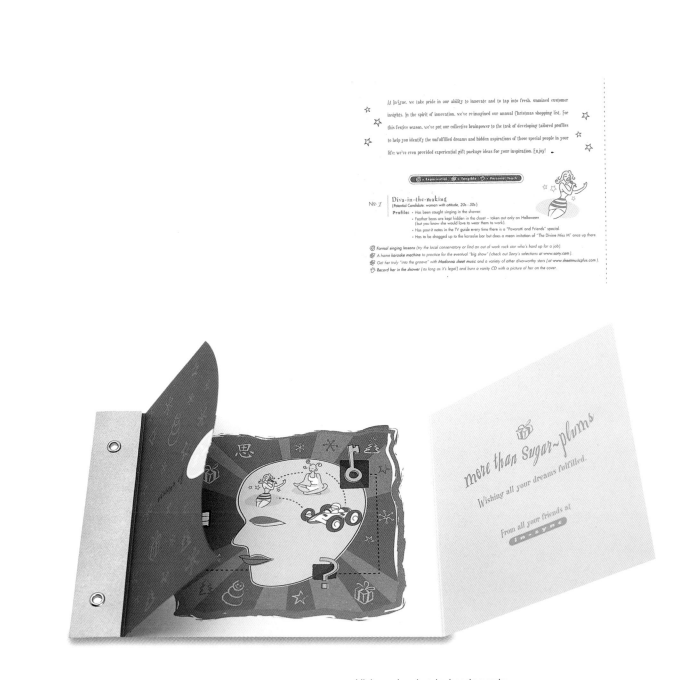

Visions-dancing-in-heads works
as a theme for a marketing
firm and its Christmas card.
The theme introduces a guide
to buying gifts for fifteen
different audience profiles.

Thinking Caps

Project: Holiday card
Creative Directors/Designers: Julie Henson, Ann Morton

Thinking Caps' designers used their holiday card to graphically react to the September 11th events in a meaningful way. They chose a message of peace and remembrance. Looking for images that say "peace," the designers conjured up a white candle. Three references there: A candle not only brings to mind the many candlelight vigils held after the crashes, it's also a symbol of the holidays. What's more, white symbolizes purity and peace.

But there was still more to say: "Remember." This time, it was the candle's fingerlike shape that neatly did the trick. Because a string tied around a finger is the universal symbol of "Don't forget," a similar tie around the candle said the same.

The sensitive holiday greeting arrived in a brown-kraft-paper-covered box. Under the lid, you see a card with a soft-edged, textured photo of a human finger tied with a burgundy string. The card is printed on uncoated, unbleached stock in dark green and burgundy ink, rather than traditional bright holiday colors, to preview the seriousness of the message.

Inside is the actual candle, tied in the same cord used for the photographed finger. The candles weren't easy to find. In the United States, the designers found the typical candle's diameter is three-quarters of an inch, too big and clunky for this purpose. They had to go to Australia (by Internet) to find a company that handmakes beeswax candles of the desired diameter and length.

The string holds a tag that reads "peace," in sans serif caps, widely letterspaced, no encroaching characters to contradict the message, reversed out of the card's colors: burgundy on one side of the tag, deep green on the other.

(When I think of the connection between a candle and a finger, a grisly-looking candle made to look like a finger comes to mind. I saw it in the Madame Toussaud's Wax Museum's gift shop. If the designers' research revealed the same, they wisely chose to ignore it. In fact, it's worth noting that it's often only taste and restraint that save designers from such judgment errors that may seem on the surface, sometimes to clients, to solve a design problem.)

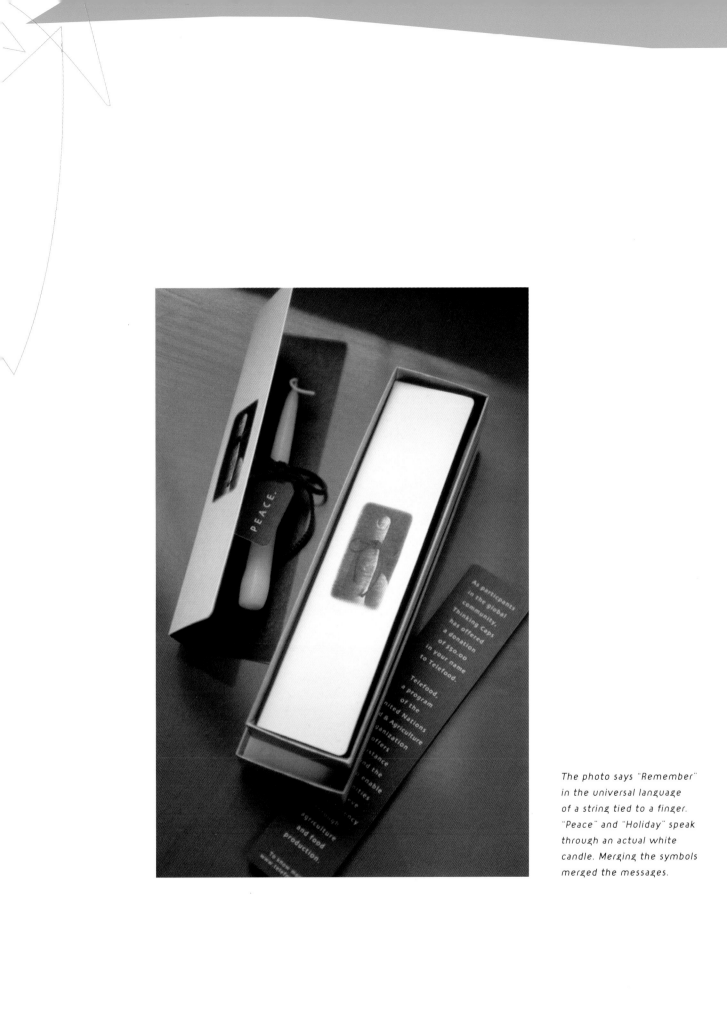

The photo says "Remember" in the universal language of a string tied to a finger. "Peace" and "Holiday" speak through an actual white candle. Merging the symbols merged the messages.

Thinking Caps

Project: Holiday card
Design Firm: Thinking Caps
Creative Directors/Designers: Ann Morton, Julie Henson

A more relaxed national climate allowed the firm to take a playful approach for its previous year's holiday greeting. To introduce and reinforce the firm's new Web site, the card picks up the site's two characters: a red ball (representing design energy), and a line (representing design potential). The animated site shows those elements interacting, then finding peace with each other. Offsite, the clever boxed card simulates animation, almost without words.

A look inside the black box reveals a three-dimensional game to let recipients react to the Web site, or just have some fun. It's a lipstick-red ball, and a lime green (chosen for its "quirkiness") paper field that's about a sixteenth of an inch thick. You can see the thickness through its central hole, drilled the perfect width to nest the ball. Recipients would have to be stodgy grownups indeed to avoid rolling around the box to try to make a hole in one with the ball. The Web site's line image plays in the box too; it's a black pipe cleaner bent to the box's square dimensions to set the boundaries of the "playing field."

Taking a break from the game leads to further inspection and revelation: the field is a stapled card. Now that the recipients have been trained in the game, all without words, they know that the hole plays a role on six inside pages. The hole forms a gap, which the red ball can fill, in a simple line drawing on each page: first it's a round ornament on a Christmas tree, then the nose of a reindeer, a cherry in a drink, the clapper on a bell, the tassel on an elf's stocking cap, and a berry hanging from holly leaves.

The back page of the card is red, so it shows through the hole to reinforce the ball's goal. Here are the only words you'll see on this piece (except for the addresses on the outside the box. They're printed on a lime-green band that binds the box): "Happy Holidays" and in tiny type, the company's name, and a brief reminder to visit the Web site print in tiny type.

In contrast to the Web site, the booklet looks low-tech, down to its binding: two exposed staples.

It's a game, it's a holiday card,
and it is a three-dimensional, low-
tech, nonverbal reflection of the
design firm's Web site. Use the ball
to play the game and to complete
the missing focal points of the line
drawings inside the card.

America Online

Project: Holiday promotion

Design Firm: And Partners, Pushpin Group

Creative Director: David Schimmel, And Partners

Designer/Illustrator: Seymour Chwast, Pushpin Group

Copywriter: Mimi Bean

Project Manager: Rachel Milder

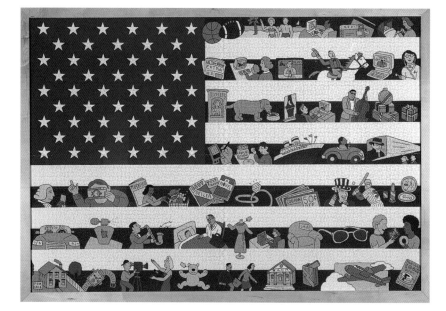

The use of jigsaw-puzzle graphics is hardly new as a way to show connection or filling in a gap (or the opposite: something that's missing). For this holiday promotional gift for America Online, what's new is the context that inspired the puzzle concept.

The holiday immediately followed the 2001 terrorist attacks in the United States; the client and the two firms that created the promotion are based in New York City, the area most affected by those attacks. The idea was to combine the puzzle concept with a U.S. flag to show how people in the United States are connected. In doing so, the company hoped to convey its role in connecting them.

Seymour Chwast illustrated the puzzle, filling the flag's red stripes with images connecting the working, playing, buying, and e-mailing public with itself. Patriotism and technology also get linked: see George Washington and Uncle Sam get technical in the fifth stripe from the top.

Each recipient got a box containing a two hundred-piece version of the puzzle, a card featuring the flag, and a key chain of a wooden version of one the puzzle pieces, with no piece duplicated on a key chain. There were plenty of pieces to choose from: the puzzles are a smaller version of a jumbo one, created to hang as a mural in corporate headquarters. It measures more than 5 feet by 3 1/2 feet, and contains more than six thousand pieces. The key chain's box came wrapped in paper printed with a puzzle pattern.

A jigsaw puzzle and its pieces in various configurations communicate patriotism and connection for an online service's holiday promotion.

Directory of Designers

344 Design, LLC
101 N. Grand Ave., Ste. 7
Pasadena, CA 91103
626/796-5148
fax: 626/658-8418
www.344design.com

88 Phases
8444 Wilshire Blvd., 5th floor
Beverly Hills, CA 90211
323/655-6944
fax: 323/655-6744
www.88phases.com

Amoeba Corp.
49 Spadina Ave., Studio 507
Toronto, Ontario M5V 2J1
Canada
416/599-2699
fax: 416/599-2391
www.amoebacorp.com

And Partners
156 Fifth Ave., Ste. 1234
New York, NY 10010
212/414-4700
fax: 212/414-2915
www.andpartnersny.com

arnagraphics
409 3rd St., 4th floor
Brooklyn, NY 11215
phone/fax: 718/768-3212
arna.grfx@verizon.net

Aue Design Studio
278 East Garfield Rd.
Aurora, OH 44202
330/995-0014
fax: 330/995-0054
www.auedesignstudio.com

August, Lang & Husak, Inc.
4630 Montgomery Ave., Ste. 400
Bethesda, MD 20814
301/657-2772
fax: 301/657-9895
www.alhadv.com

BBK Studio
648 Monroe Ave. NW, Ste. 212
Grand Rapids, MI 49503
616/459-4444
fax: 616/459-4477
www.bbkstudio.com

Beth Singer Design
1912 17th St. NW
Washington, DC 20009
202/483-3967
fax: 202/232-7107
www.bethsingerdesign.com

Blok Design
822 Richmond St. West, Ste. 301
Toronto, Ontario M6J 1C9
Canada
416/203-0187
fax: 416/203-0075
blokdesign@earthlink.net

Cahan & Associates
171 2nd St., 5th floor
San Francisco, CA 94105
415/621-0915
fax: 415/621-7642
www.cahanassociates.com

Cannondale
Gewerbestrasse 25
CH-4123 Allschwil
Switzerland
+41-61 4879 481
fax: +41-61 4879 485

Cavarpayer
Berislavićeva 14
10 000 Zagreb, Croatia
+385 1 4872 420
fax: +385 1 4872 427
www.cavarpayer.com

Chermayeff & Geismar Inc.
15 East 26 St.
New York, NY 10010
212/532-4499
fax: 212/889-6515
www.cgnyc.com

Design Machine
648 Broadway #202
New York, NY 10012
212/982-4289
fax: 212/982-1260
www.designmachine.net

Dieste Harmel & Partners
3102 Oak Lawn, Ste. 109
Dallas, TX 75219
214/800-3500
fax: 214/800-3540
www.dieste.com

DiMassimo Brand Advertising
20 Cooper Square, 6th floor
New York, NY 10003-7112
212/253-7500
fax: 212/228-8810
www.dimassimo.com

Dorr Design Associates, Inc.
1123 Broadway, Ste. 911
New York, NY 10010
212/675-0798
fax: 212/675-0946
www.dorrdesign.com

Dotzero Design
8014 SW 6th Ave.
Portland, OR 97219
503/892-9262
fax: 503/245-3791
www.dotzerodesign.com

Doyle Partners
1123 Broadway, Ste. 600
New York, NY 10010
212/463-8787
fax: 212/633-2916
www.doylepartners.com

Ergonomidesign
Box 14004
16714 Bromma, Sweden
+46-8-26 25 25
fax: +46-8-26 82 83
www.ergonomidesign.com

Fork Unstable Media GMBH
Juliusstrasse 25
D-22769 Hamburg, Germany
+49 (40) 432 948-0
fax: +49 (40) 432 948-11
www.fork.de

Gardner Design
3204 E. Douglas
Wichita, KS 67208
316/691-8808
fax: 316/691-8818
www.gardnerdesign.net

Gee + Chung Design
38 Bryant St., Ste. 100
San Francisco, CA 94105
415/543-1192
fax: 415/543-6088
www.geechungdesign.com

Grasp Creative, Inc.
8150 Leesburg Pike, Suite 513
Vienna, VA 22182
703/760-0061
www.gograsp.com

Greenfield/Belser Ltd.
1818 N St. NW, Ste. 110
Washington, DC 20036
202/775-0333
fax: 202/775-0402
www.gbltd.com

Gregory Thomas Associates
2812 Santa Monica Blvd., Suite 201
Santa Monica, CA 90404-2410
310/315-2192
fax: 310/315-2194
www.gtabrands.com

Grey Worldwide Toronto
1881 Yonge St.
Toronto, Ontario M45 3C4
Canada
416/486-0700
fax: 416/486-7340
www.grey.net

Group Baronet
2200 N. Lamar #201
Dallas, TX 75202
214/954-0316 x231
fax: 214/855-0460
www.groupbaronet.com

Hornall Anderson Design Works, Inc.
1008 Western Ave., Ste. 600
Seattle, WA 98104
206/467-5800
fax: 206/467-6411
www.hadw.com

IE Design, Los Angeles
1600 Rosecrans Ave.
Building 6B, Ste. 200
Manhattan Beach, CA 90266
310/727-3500
fax: 310/727-3515
www.iedesign.net

Interbrand Avalos & Bourse
La Pampa 1351
C 1428D2A
Buenos Aires, Argentina
+541 147 88 9665
fax: +541 147 82 5803
www.avalosbourse.com.ar

Interrobang Design Collaborative
2385 Huntington Rd.
Richmond, VT 05477
802/434-5970
fax: 802/434-6313
www. interrobangdesign.com

JDG Communications, Inc.
200 Little Falls St., Ste. 410
Falls Church, VA 22046
703/533-0550
fax: 703/533-0554
www.jdgcommunications.com

Kabenge Design
14026 Vista Drive, Ste. 82A
Laurel, MD 20707
301/369-3599
fax: 240/359-7174
www.portfolios.com/Kabenge

Tim Kenney Marketing Partners
3 Bethesda Metro Center, Suite 630
Bethesda, MD 20814
301/718-9100
fax: 301/718-2811
www.tkm2.com

Ute Kraidy
Silver Spring, MD
301/592-0997
phone/fax: 703/812-5176
ute_kraidy@e-mail .com

LPG Design
410 E. 37th St. N
Wichita, KS 67219
316/832-3382
fax: 316/832-3293

Latina Media Ventures LLC
1500 Broadway, Ste. 700
New York, NY 10036
212/642-0213
fax: 917/777-0861
www.latina.com

Ronnie Lipton
P.O. Box 59555
Potomac, MD 20859
301/656-4916
fax: 301/656-9429
ronlipton@aol.com

Lowercase, Inc.
213 W. Institute Place, Suite 311
Chicago, IL 60610
312/274-0652
fax: 312/274-0659
www.lowercaseinc.com

MDB Communications, Inc.
1050 17th St., Ste. 250
Washington, DC 20036
202/835-0074
fax: 202/835-0656
www.mdbcomm.com

Magma [Büro für Gestaltung]
Bachstraße 43
D-76185 Karlsruhe
Germany
+49-721-929 19 70
fax: +49-721-929 19 80
www.magma-ka.com

The Marlin Company
1200 East Woodhurst, Bldg. V
Springfield, MO 65804
417/887-7446
fax: 417/887-3643
www.marlin-thing.com

Mek-aroonreung/Lefebure
1735 North Fairfax Drive, #13
Arlington, VA 22209
202/277-1973

MetaDesign North America
350 Pacific Ave., 8th floor
San Francisco, CA 94111
411/627-0790
www.metadesign.com

**Michael Gibbs Illustration
and Design**
13908 Stonefield Lane
Clifton, VA 20124
703/502-3400
fax: 703/502-3406
www.michaelgibbs.com

Mires Brands
2345 Kettner Blvd.
San Diego, CA 92101
619/234-6631
fax: 619/234-1807
www.miresbrands .com

Mirko Ilić Corp.
207 E. 32
New York, NY 10016
212/481-9737
fax: 212/481-7088
www.mirkoilic.com

Neo Design
1048 Potomac St. NW
Washington, DC 20007
202/342-6470
fax: 202/342-9139
www.neo-design.com

Niklaus Troxler Design
Bahnhofstrasse 22
Postfach
CH-6130 Willisau
Switzerland
+41-41-970 2731
fax: +41-41-970 3231

Novapolis
250 Avenue des Iles
Zi des Iscles BBP93
13833 Chateaurenard
France
+334 909 43 100
fax: +334 909 47 142
novapolis@novapolis.com

OmniStudio Inc.
1140 19th St. NW. Ste. 320
Washington, DC 20036
202/785-9605 Ext.21
fax: 202/785-9609
www.omnistudio.com

**Parsons School of Design,
Promotion Design**
66 Fifth Ave., Room 818
New York, NY 10011
212/229-8905
fax: 212/229-5113
www.newschool.edu

Pentagram
204 Fifth Ave.
New York, NY 10010
212/683-7000
fax: 532-0181
www.pentagram.com

Pohuski Studios, Inc.
36 South Paca St., Ste. 315
Baltimore, MD 21201
410/962-5404
fax: 410/332-0180
pohuski.studios@verizon.net

Poulin + Morris
286 Spring St., 6th floor
New York, NY 10013
212/675-1332
fax: 212/675-3027
www. poulinmorris.com

Pushpin Group
18 E. 16 St.
New York, NY 10003
212/255-6456
fax: 212/727-2150
www.pushpininc.com

Rhonda Weiner Graphic Design
New York, NY
phone/fax: 212/966-6724
rhondaw@walrus.com

The Riordon Design Group, Inc.
131 George St.
Oakville, Ontario L6J 3B9
Canada
905/339-0750
fax: 905/339-0753
www.riordondesign.com

RRhinehart Design
1925 Gough St.
Baltimore, MD 21231
410/327-8554
www.rrhinehart.com

Sagmeister Inc.
222 West 14th St. Ste. 15a
New York, NY 10011
212/647-1789
fax 212-647-1788
www.aheartunbroken.org

Sayles Graphic Design
3701 Beaver Ave.
Des Moines, IA 50310
515/279-2922
fax: 515/279-0212
www.saylesdesign.com
www.artfightsback.com

Skaggs Design
1262 Mason St.
San Francisco, CA 94108
415/395-9775
and
233 Spring St., Ste. 1002
New York, NY 10013
646/336-1458
fax: 646/336-1453
www.skaggsdesign.com

Slavimir Stojanović/Futro
Arih Advertising Agency
Celovska 32
1000 Ljubljana
Slovenia
+386/41-320-597
www.futro.co.uk

Smart Design
137 Varick St., 8th floor
New York, NY 10013
212/784-4011
fax: 212/243-8514
www.smartdesignusa.com

Starshot GmbH & Co. KG
(see Magma)
www.starshot.de

Suka & Friends Design, Inc.
560 Broadway, Ste. 307
New York, NY
212/219-0082
fax: 212/219-0699
www.sukadesign.com

Theater Grottesco
551 W. Cordero Rd., #8400
Santa Fe, NM 87505

Thinking Caps
815 North First Ave., Ste. 3W
Phoenix, AZ 85003-1448
602/495-1260
fax: 602/495-1258
www.thinkingcaps.net

Thirst
132 W. Station St.
Barrington, IL 60010
847/842-0222
fax: 847/842-0220
www.3st2.com

Thumbnail Creative Group
611 Alexander St., Ste. 403
Vancouver, BC V6A 1E1
Canada
604/736-2133
fax: 604/736-5414
www.thumbnailcreative.com

James Victore, Inc.
47 South Ave.
Beacon, NY 12508
845/831-9375
fax: 845/831-9370

Visual Dialogue
4 Concord Square
Boston, MA 02118
phone/fax: 617/247-3658
www.visualdialogue.com

207

Acknowledgments

My deep appreciation to my husband, Jeff Young (not least for keeping me fed during this process!); to my parents, Shirley and Nathaniel Lipton; and to others who've gone out of their way to support this book, including the hundreds of designers who generously contributed their work, and:

Jessica Fagerhaugh: Jam Communications
Kim Farcot: Savoir-Faire Design
Tim Kenney: Tim Kenney Marketing Partners
Mary Fichter: The Art Directors Club
Alessandra Marinetti
Lenira Ohnesorge
Julie Perlmutter: The Creative Network
The Rockville, Maryland, Public Library
 Information Desk

About the Author

Ronnie Lipton specializes in training and consulting on effective design and writing. The author of *Designing Across Cultures: How to Create Effective Graphics for Diverse Ethnic Groups,* she's an award-winning journalist and publication designer. She teaches journalism courses at George Washington University's Center for Professional Development and graphic design at the University of Maryland. For more than eight years, she was editor and art director of *In House Graphics,* a subscription newsletter about effective, low-budget design. Ronnie lives with her husband, Jeff Young, in Bethesda, Maryland.

If you've got an information-design story or comment. I'd like to hear it. Please contact me at ronlipton@aol.com.

Thank you for your interest in this book.